VOICES OF AMERICA

Race and Change in
HOLLYWOOD
FLORIDA

VOICES OF AMERICA

Race and Change in
HOLLYWOOD
FLORIDA

Compiled by
Kitty Oliver

Copyright © 2000 by Kitty Oliver.
ISBN 0-7385-0569-2

Published by Arcadia Publishing,
an imprint of Tempus Publishing, Inc.
2 Cumberland Street
Charleston, SC 29401

Printed in Great Britain.

Library of Congress Catalog Card Number: 00-103201

For all general information contact Arcadia Publishing at:
Telephone 843-853-2070
Fax 843-853-0044
E-Mail sales@arcadiapublishing.com

For customer service and orders:
Toll-Free 1-888-313-2665

Visit us on the internet at http://www.arcadiaimages.com

Cover: *Workers in the mid-1930s moving fruit from railroad lines to ships at Port Everglades. (Gene Kelcy/Ft. Lauderdale Historical Society.)*

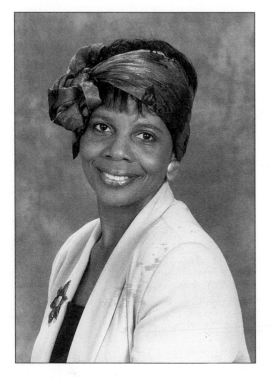

Kitty Oliver is a veteran South Florida journalist and writer-in-residence at Florida Atlantic University's College of Liberal Arts. A native Floridian, she has written, lectured, and produced documentaries on ethnic diversity in the Broward County area since the 1980s.

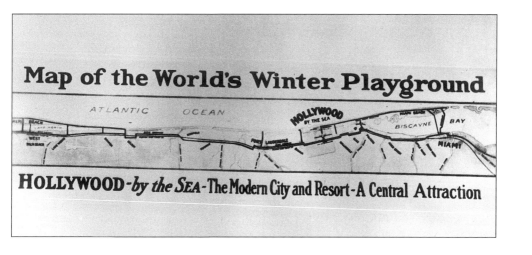

Contents

Acknowledgments	6
Foreword	7
1. Two Sides of the City: Promise and Pain	9
2. The Early Years: Migrations and Memories	23
3. The Sixties: Lives Converge	55
4. Race: The Immigrants' Perspective	83
5. Voices: A City in Transition	107
Epilogue	126
Photograph Credits	128

South Florida

ACKNOWLEDGMENTS

This book is based on the community oral history project "Migration Stories: Crossings of the Racial Divide" conducted in the fall of 1999, sponsored by the Florida Humanities Council, the Broward County Library, the city of Hollywood, the Women's History Coalition, the National Conference for Community and Justice, Florida Atlantic University's College of Liberal Arts, and *The Sun-Sentinel* newspaper.

Appreciation goes to the following: Bob Issacs, for research assistance; Dr. Marvin Dunn, the Broward County Historical Commission, the Hollywood Historical Society, Inc., the Fort Lauderdale Historical Society, and Bernard Kouchel, Broward Jewish Genealogical Society, for additional research information; Holly Baublitz, Catherine Hall, and Joan Cartwright for transcriptions of interviews; and photographers Taimy Alvarez, Candace West, and Susan Gillis. Other photo sources include the Florida State Archives, the Broward Section of *The Herald*, the City of Hollywood Records and Archives, "People's Friends" Mary and Charles Washington, and Fred and Alfreda Pinkston. And a special thanks goes to Jeff Schattner, Cheryl Frost, Mark Gauert, and *Sunshine* magazine, where excerpts from this project were first published.

Most of all, thank you to the Broward County residents who shared their Hollywood-area memories for archival purposes and this publication: Cathleen Anderson; Helena Ash; Evelyn Baez-Rojas; Gloria Hepburn Bridgewater; Claude David; James Dee; Nancy Dee; Julio De Los Rios; Joyce Dent; Sam Dietz; Sandy Eichner; Kee June Eng; Helen Franks; Bob Gossett; Henry Graham; Susan Abrams Heyder; Pedro "Peter" Hernandez; Jose "Pepe" Lopez; Albert McDonald; Eileen McDonald; Dorothy McIntrye; Marvin Merritt; Martin Rennalls; Reeta Mills; Elisha Moss Jr.; Cyril T. Pinder Sr.; Leonard Robbins; Deotha Roby; Robert Ryle; Guithele Ruiz; Greg Samuel; Leroy Saunders; Kevin Swan; Errol Sweeting; Edna Bain Symonette; Paula Tejeda; Annie Thomas; Ramon Torres; Diana Wasserman Rubin; Joe Wheeler; Vera Williams; and Mr. William Horvitz, in memoriam.

FOREWORD

Fear. That's the one emotion I didn't expect to feel.

After all, for two decades I had made a living as a journalist knocking on the doors of people's lives to gather information. And I was no novice at dealing with race-related issues, either.

As one of the first black journalists in the greater Fort Lauderdale/Broward County, FL area, hired in 1971 to cover the entire county, not just its minority communities, I sat in on late night meetings where angry white parents spilled their outrage to me against plans to bus their children into black neighborhoods for court-ordered desegregation. I watched black activists plot demonstrations to break down employment barriers. In 1974, a county-wide open housing ordinance was finally passed, by just one vote of the County Commission, after two years of trying, paving the way for minorities to rent and buy homes, especially in middle-class areas. I lent my voice to the small chorus of people who pleaded for the law.

I've met thousands of transplants from other parts of the United States who have flocked to this area with sparks of the same wishfulness that brought Ponce de Leon to Florida 500 years ago. I've seen natives return home like weary travelers to make a new start in their old home, which has grown so much it's nearly unrecognizable. The immigrants from other countries have added spice to the mix, forcing us to reevaluate our sense of roots and culture. Often during these encounters, the subject of race relations would surface through comments such as "Attitudes here are so different from other parts of the country," "There is no sense of history—for the white or black community," and "People don't interact here across racial lines."

Is that true? I began to wonder. And if so, why?

All of this led me to conduct research for an oral history project on race relations experiences, interviewing people about their "crossings of the racial divide." As a starting point, I planned to look at the pivotal period when change swept the nation with desegregation starting in the 1960s. Since its incorporation in 1915, Broward County has been a community in transition. Once a rustic frontier area of palmettos and mangroves, then a seasonal winter tourist community, it is now a bustling area of about 1.5 million people—fertile ground to dig.

This metropolitan reputation was surprisingly cemented in a *Money* magazine article in the late 1990s that touted the town of Hollywood, once just a bedroom community in the southern part of the county sandwiched between better known Fort Lauderdale and Miami, for having the black-white ethnic makeup that pretty much mirrors what America will look like by the year 2022. As I researched, I found more than I expected.

The memories of the 42 residents, recorded for the county's historical archives, span 75 years of racial and ethnic change. They are whites and African Americans born in South Florida or longtime residents; Hispanics of Cuban, Dominican, and Puerto Rican descent; Bahamians and Jamaicans; Haitian; Chinese; and South American. They present a tableau of perspectives on the American racial experience—a multi-cultural salad bowl of personal recollections rarely shared beyond the confines of their group.

What *I* will remember most, however, as I embarked upon this peculiar attempt at dialogue, is this feeling that would come upon me—suddenly, sometimes.

During a preliminary call to introduce myself to a stranger and ask for his or her participation, I would hear a voice on my end that I didn't recognize. My words would sputter and speed off at such a dizzying speed you would think I was trying to hoodwink a Floridian into buying a snowmobile. I was on guard, expecting rejection, preparing a rebuttal. Or, a wave of trepidation would sweep over me as I approached certain homes where I knew I would encounter some unhealed racial wounds. At times I would pull onto the swale of some quiet street and take a few deep breaths until I felt composed enough to ring the doorbell for an interview, unsure of what to expect, especially from whites. Would it be too painful—for all of us? Should we even try?

It became clear to me that people wanted to talk about race relations, all right, but not necessarily how far they had come. In most cases blacks, whites, and even immigrants still live racially separated lives outside of work or occasional activities. Still, they had stories they definitely wanted to tell—offering glimpses behind the walls.

Their stories cross many borders, overlapping neighborhoods within Hollywood and adjacent communities, and seeping into surrounding smaller towns such as Dania Beach and Hallandale, just one cross street away. Some start in the Northeast, Midwest, or other countries, but all converged here. Many of these are older black voices rarely heard from before; others were teenagers of the historical 1960s who, at midlife, are reflecting on racial change and its effect on their lives. They touch on the indignities of Jim Crow laws: segregated beaches, buses, and restrooms and fountains marked with "white" and "colored" water that piqued the curiosity of both white and black children who longed to sample both. They share observations about city projects where different races and ethnic groups sometimes join forces for a cause, and they cite some progress that has been made—personally and as a community—over the decades.

But mostly they shared memories, candidly. Many said they were surprised at the things from the past that surfaced in the process of the telling—the good and the bad.

Once I relaxed enough in their living rooms with a cup of morning coffee, or at their dining room tables after the dinner dishes were cleared, or in a quiet corner of their offices at the start or end of a workday, all I had to do was listen as I recorded their words—they seemed to be talking to each other. And I would try to make some sense of our collective past as Americans, too.

CHAPTER 1

TWO SIDES OF THE CITY: PROMISE AND PAIN

Master land promoter Joseph Young helped trigger the great Florida land boom of the early 1920s with his grandiose idea of a "Dream City." Through the mangroves and wild coastline, his imagination carved out what he called Hollywood-by-the-Sea. It would have golf courses, country clubs, lakes, circles, a luxury beach hotel, and a main street—Hollywood Boulevard—that would be transformed with every stage of the town's development from then until now. The books History of Hollywood *and* Tales of Old Hollywood *speculate that Young may have named it Hollywood because of a stay in California at one time. For sure, he used show business publicity experts to help spread the word to potential settlers, promising "a city for everyone—from the opulent at the top of the industrial and society ladders to the most humble of working people."*

By the time Young died in 1934, his "Dream City" idea had been pummeled by hurricanes, the stock market crash, and personal financial misfortunes. A cartoonist dubbed it a city "Born 30 Years Too Soon."

William Horvitz remembers how his father, Samuel Horvitz, and Hollywood, Inc. took over as developer when it looked like the Young dream would die. They held on through the post–World War II building boom: "He was a great promoter, a great salesman, but a terrible man with figures. That was [my father's] specialty. But he also was a very far-seeing person. A lot of the land we owned was in Port Everglades, and he often talked to me about how Port Everglades was going to be this great port carrying merchandise from South America.

9

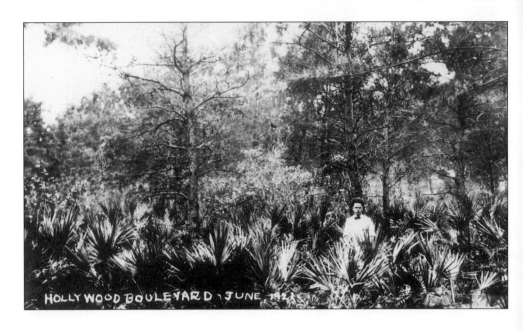

Hollywood Boulevard, June 1921

"My father was very, very optimistic about the future of Hollywood, and he acquired his interest in 1930, and he carried that vacant land for years with no income. It was a real hardship for him. He didn't have a great source of funds, and he had to improvise to get enough money to pay the overhead he had down here. He lived in Ohio, and he owned two newspapers that weren't making money and a road construction business that wasn't making money, so it was a struggle. But he was optimistic about the future of South Florida that he held on. Most people didn't.

"We made decisions [on development] on the basis of lots that we owned. Surprisingly, the company was accused of holding back the development of Hollywood. When things got going, in a different political situation, we were accused of trying to develop and ruin the city. I remember showing a newspaper reporter an article with the accusation that we were holding back development of the community, and he couldn't believe it, but it was there.

"An awful lot of people who moved to South Florida had been in the service, down here. They had training facilities all over the place. They liked it and came back here. You could get a medium-sized house for under $100,000—fairly good-sized house. There were houses available in Hollywood, not having anything to do with us, for $6,000 or $7,000, west of 56th Avenue. The price of the housing [influenced the type of development], like what type of employment people had, etc. [The Lakes] was the most affluent area. [Hollywood Hills] was next—seemingly nice housing that went down to a much lower price. But the new areas, of course, some were much higher priced. When we developed Emerald Hills, which wasn't developed until 1964, that was pretty high-end. Has a country club golf course, etc. It ran the whole gamut.

"The social life was really that of a small community. I came from Shaker Heights, Ohio, a suburb of Cleveland. It was a much larger community, quite affluent. At that time, it was a nicer place

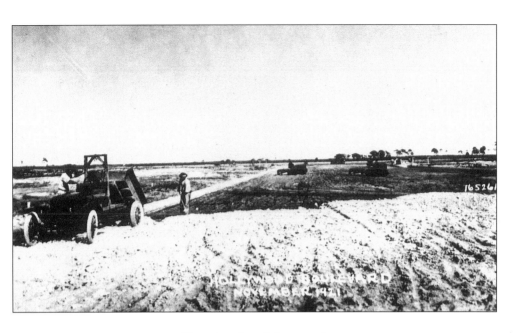

Clearing land for roads

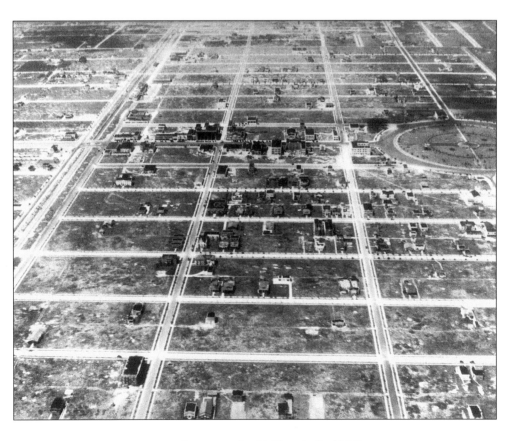

Development in Hollywood, 1926

to live than Hollywood. One of the other things I remember is everybody closed up on Wednesday afternoon, and a lot of the businesses were open Saturday morning, which is the old tradition. Midweek, doctors went off to play golf. I don't know. The community was much smaller. The major attraction for those who could afford it was the Hollywood Beach Cabana Club. That was subsequent, but I remember belonging to a cabana club. The townhouse in the middle of the circle in Hollywood where Publix now is also had a cabana club where you could go and swim. [Hollywood Boulevard] was diagonal parking. I think they eliminated that very soon. We had no air conditioning in the summertime. It had some pretty ugly spots. Everything stopped east of [Interstate] 95."

Leonard Robbins moved to Broward County in 1925 and settled in Hollywood in 1947 when he started his law practice. He picks up the story: "The very, very rich people who came down to Florida—I mean, rich people, that's over $25 to $30 million—didn't settle here. They settled in Hobe Sound, Palm Beach, Delray, a few in the Gables, and a few on the beach. The medium rich people—that's people who have $2 to $3 million to the other figure I mentioned—they settled in Ft. Lauderdale; they settled in Boca Raton; they settled in the Gables and on the beach. The retired civil servants settled in Hollywood. A few rich people—they're the Mailmans of the world and the Horvitz family—but Hollywood was never a town for real big wealth. And it wasn't a county seat, so even though it's grown from 5,000 to about 126,000, and it's only about 25,000 or 30,000 less than Fort Lauderdale, it's not the metropolitan center that Fort Lauderdale is."

The roots of the county were firmly planted first in Fort Lauderdale. That's where Robbins grew up and experienced the early racial and ethnic frictions: "I came down here when I was four years old. I could already read and write. I started school when I was barely six. At that time, my father owned a clothing store, and I wasn't aware of much of anything. After I started school, I became aware of the fact that I was not Christian, but I was Jewish because I had a few classmates who called me names that were identified with being Jewish and part of them was 'bastard.'

"My father [owned] the first really good men's clothing store in Broward County. Archie Robbins was his name, and he had 'Robbins, Inc. Men's Store,' which is right in front of the old Tropical Arcade. When we first came down to Fort Lauderdale there were maybe five or six Jewish families in the whole community. That's all there were. I remember the Ku Klux Klan riding through town in their cars with their sheets, riding down the streets, and all the kids trying to get out to the storefronts and watch them go by, wondering what in the hell they were doing. Well, they weren't out for Jewish people because there weren't enough of us to make any difference. They were trying to intimidate the black people and anyone else who didn't agree with them. And I didn't even attach much importance to it because nobody was hunting me out. If you're not involved in it, you don't take the interest in it. Most people, if they're not threatened, don't care. My dad had that clothing store there and about 1936 or '37, about that time, the white Christian community became aware of it, and they didn't want to go into my daddy's store, really. So they got together, and they put up the money for the competitor's store to compete with him. They eventually went broke, too.

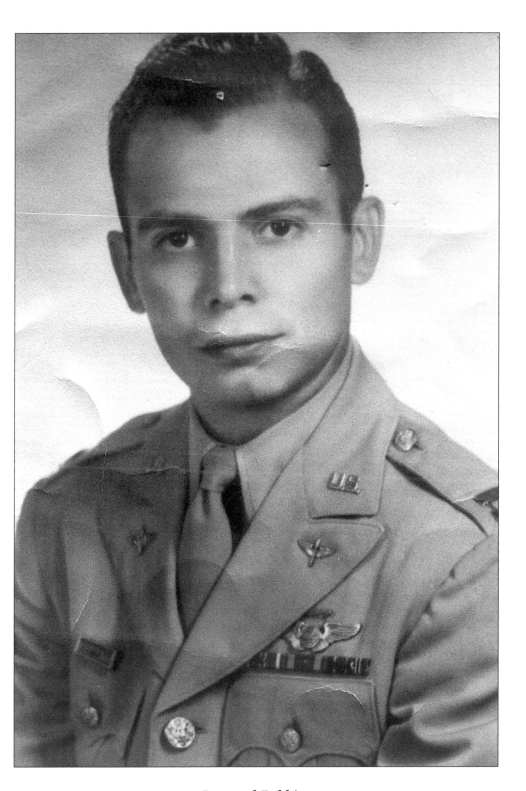
Leonard Robbins

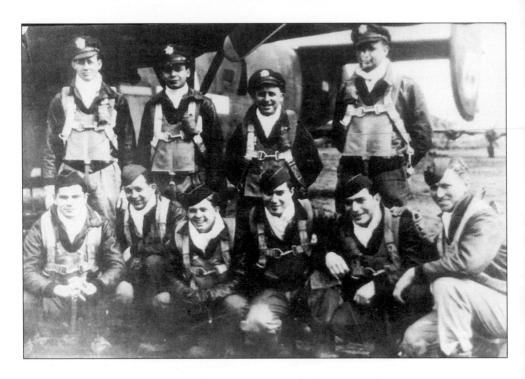

Capt. Leonard Robbins (standing, second from the left) and a bomber crew

"When I came back from the war in 1947, I actually graduated from law school. That's when I was admitted into the bar. I was working in my father's store in Christmas of '47, selling clothes. In fact, I was selling clothes the day the telegraph came in advising me that I had passed the bar. Now, trying to get a job, I couldn't get a job. One lawyer in Fort Lauderdale had offered me a job, but the big firms didn't. One of them told me, 'I don't hire any Jews.' So here I am, a veteran of World War II. I came out of the war as a captain . . . a highly decorated war veteran. I had six air medals and two Distinguished Flying Crosses, a graduate of Harvard Law School—which should be some recommendation—and nobody wanted to hire me. I looked around, and Hollywood had 5,000 people in it. There were 12 lawyers [in that area] south of the Davie cut-off canal, and I was the 13th. So I opened up a law office. I think the first year I did pretty well. I made 72 hundred bucks. That was the total for the whole year. The next year I went into a partnership.

"My first thought, really, of the racial questions didn't come until about the middle of the Depression. In those days, we were able to hire some help for a very small amount of money. And that's when I first became aware of these things because most of the people servicing households were black. And they worked for a small amount of money, but they did get their meals. And food was a problem. Everyone went to a barbecue because you got a free meal. And about that time I became aware of the differences between races. And some small minority of people had religious prejudices. I was a cracker like the rest of the kids; nobody paid any attention to that kind of thing.

"Religious difference didn't become very prominent in Broward County

until 1936, about the year before I got out of high school. When they built the . . . first hotel in Fort Lauderdale . . . they had a big sign out front, 'restricted clientele.' I didn't even know what it meant until my father explained it to me, and that meant that Jewish people were not welcome. And of course, black people weren't welcome anywhere, even on the east side of the tracks.

"I went to the beach. That was all right. You just couldn't stay in the hotels. Everyone ran up and down the beach, drove their cars up and down the beach. Kids rode up and down the beach together. That was nothing. Black people couldn't go to the beach then. They didn't even have a beach to go to because if they came out on the beach in Fort Lauderdale, the police came up and run them off. They didn't have any ordinance about Jewish people, but they sure had them about black people.

"The lady who cooked for us was our maid. Her friends would come over to the house and visit, and they recruited me to play in their whisk games. That's where I learned to play whisk. Me and the people who were working for families would play whisk together. And I became acquainted with black people and some of their problems. That's when I first got to it. I really became more aware of it after I graduated from the University of Florida and went to Harvard Law School. When I was at Harvard Law School we had black students. And, of course, I spent one year up north going to high school, at a high school in Massachusetts. And the schools, they were mixed races. Then, of course, I became aware of it in the service. I was a navigator with a heavy bomber outfit. At that time we were flying up over Germany . . . there were no fighter escorts because the P-38s couldn't fly up that far for that many hours, didn't have enough gas. And it wasn't until the P-51s came, fighter groups, that they brought in an all-black fighter squadron who was an escort for us. And that's the time when you became really grateful for anyone who was up there flying in a fighter plane. [They] kept the Messerschmitts and the Focke-wulfs from shooting your rear end off. And they were our little brothers, so to speak, because they would get up above us, and you could hear them call on the radio, 'Big brother, big brother we're here. Little brother's here. Little brother's here.'

"The first time I would believe that I really had black friends—and I use the word friends very wisely because you don't have too many friends in this world—was when I came back to law school after the war. We had a softball team in our dormitory—not dormitory, building that the school provided that we lived in. We had three of the players on our team [who] were black, and some of our classmates were black, and that's when I started forming some good friendships. The close friendships really I had were of people of the same color. Playing together, living together, going to class together, eating together. In fact, we had a few famous people there.

"We had a black-tie party for my 70th and a black tie party for my 75th, and I thought of what black people were at my parties that I knew well enough to invite. There were only three or four couples. And yet, I look at my partners who are . . . liberals; they're not conservatives like I am . . . and say to them, 'Tell me something. All of y'all are pro-black. How many of you have had a black person in your house for dinner? I have. How many of your kids have ever slept over at a black friend's house for a sleepover or had them over to your house? I have.'"

*R*eeta Mills was born in Hallandale, a small town just south of Hollywood, behind walls as formidable as the gated enclaves of homes and condominiums that dot the shoreline today. Signs marked "colored" meant restrictions in public accommodations from railroad stations, to buses, to restrooms, to cemeteries. Black workers who cleared land, built houses, and loaded at docks were forced to live "across the tracks," away from whites, often in substandard conditions. But Mills, who grew up in the 1950s and 1960s, recalls a thriving community: "My father's grandfather migrated here from Eleuthra [in the Bahamas]. My father was born in Miami, and when they were little [the family] migrated to Hallandale and built a home here. They did farming here before it was against

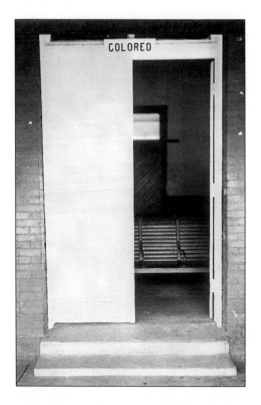

Jim Crow signs exhibiting separation of races in Florida

the code. I remember, as a little girl, at my granddad's house, they had two lots on each side of the house. The house sat on one lot with two lots to the right and two to the left. He would use the two to the right for sweet potatoes and collard greens and something else he had growing out there. To the left, he was in the construction business, so that's where he kept his work supplies. He was in transition. He was part farmer, part builder and his house was reflective of that.

"My mother's parents were restaurant operators. In fact, the building is still around this corner. They built that building in the '30s. Back then, you could build a building with a business downstairs and living quarters upstairs. It's against code, now. But that's what my grandparents did. They had a family-style restaurant where you could get ice-cream cones, breakfast, lunch, and dinner—all home-cooked meals. That's the environment that we grew up in.

"My grandmother owned the restaurant. She came from the west coast of Florida. They initially were up in Putnam County, out from Gainesville. Then, they migrated to Lake City. Then—and this is the same thing that brought my husband's parents here from Georgia—this section of Florida had a reputation and was, and still is, called the Gold Coast. What brought a lot of minorities here was employment opportunities. The very rich lived on the other side of the track and the Intracoastal, and they owned property on the beach. They would live here in the wintertime. [Whites] had an entourage that they would bring with them. They would go back up north in the summertime. I have a stepdad who made a living maintaining properties for northerners who would vacate this area in the summer. That was his job, to keep the lawns cut, keep the house checked. When they were here, he was the yard-

keeper and ran errands. He was the groundskeeper and maintenance man in the summer. When they were away, he was the yardkeeper and property manager. But they were very good to him. They bought him a truck so he could get back and forth to where they needed him. There was a group of them. Some lived in Hollywood Beach, some in Dania. Everybody lived close or near the Intracoastal. What I realized, as an adult, was that most of those homes had black women in them who were maids and cooks. A lot of them came from these communities. What I learned was that the maids, cooks, butlers, and yardmen—all of this marrying, girlfriend and boyfriend stuff—started over there on the job.

"My grandmother, who had the restaurant, had six rooms over the restaurant, and as a kid, I have these very fond memories. The black limousines were parked behind the restaurant because the chauffeurs who drove those people down here could not live on the beach, so they would come over here to look for a place to live. And over the years, she built up a clientele of regulars who would come to Miz Dora and the Blue Moon. For us kids, it would be so exciting. There would be five or six of those big, black, shiny limos, and the guys all wore uniforms. When the season was over, they would be gone, and you wouldn't see them until next year.

"There was a bar in Hallandale called The Palms owned by a white man. He had the vision to bring top name entertainment to his facility that he could make money, and did he make money. The Palms was a uniquely built structure at Pembroke Road and 8th Avenue, a drive-in club, like going to a drive-in theater. You could sit in your car. The stage was high enough. The club had a half wall. You could go in the front and pay to watch the entertainers. People came from near and far. Jackie Wilson, Jerry Butler, James Brown was here every month, the Drifters, everyone who was somebody back in those days. This was in the '50s, before Motown. He put up a motel a block away, and that's where the entertainers would live when they performed at The Palms. The junior high school was just west of that, and we lived east, so we had to walk past The Palms and the motel to get home in the afternoon. It was a treat because you'd want to see who you could see, who was in town that week for the show. By that time, it's 3 o'clock in the afternoon, and they're up from having performed most of the night and getting their rest. Sometimes, they'd be sitting out, and they'd wave at you. They had a teenage night at The Palms. You were supposed to be 14 or 15 to get into the teenage night, but I was 12, and I was big. I matured physically, fast. My aunt, my mother's favorite sister, was a Jerry Butler fan, and she didn't want to go by herself, and she took me to teenage night. That was the first time I had ever seen a performance live. Jackie Wilson used to be here all the time. That put Hallandale on the map. Tri-county black people knew about The Palms in Hallandale. That crowd created business for others on the strip. This was a very vibrant corridor in those days. Once integration came, everybody wanted to go to [Miami Beach] to the Deauville and these places, and that hurt the business here.

"Something else that was very vibrant in those years was the black taxi companies in this community. My biological father and two of his cousins ran a taxi service because there was no bus service through here, and once they got across the tracks to get to a bus, they had to ride the back of the bus, or they couldn't ride it at all. I went with my aunt somewhere on the bus. I remember she was dressed up, and I was dressed up, and I remember getting on the bus and

17

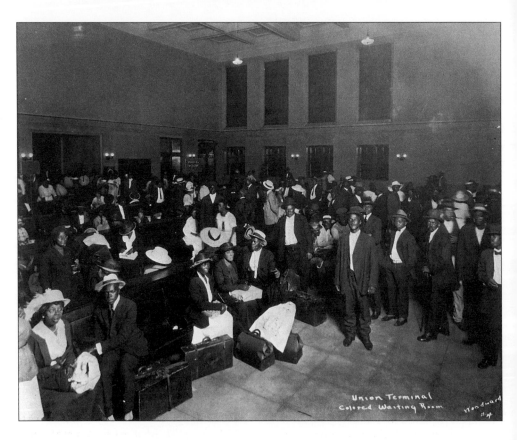

A colored waiting room in a train station

having to go all the way to the back, and we were the only ones back there. But that's the only time. I want to think that she took the bus as a last resort, that wherever we were supposed to go, we were supposed to go some other way. Somebody was supposed to pick us up or something, and that didn't happen, and she just decided to take the bus. That was the only experience I remember, riding the bus when you had to go to the back. You know what; they did such a good job of protecting us and insulating us, and we were lucky enough to live in a community where the white people were very kind. Other than that bus ride—and then, too, I didn't understand what was going on with the difference, until I was older. I never experienced any outright racial hostility until I left this area as a high school graduate to go to college."

Joe Wheeler grew up in the Washington Park section of Hollywood adjacent to Hallandale and close to Miami in the 1950s and 1960s as well. He remembers a much bleaker time—in Broward County, at least: "It was open space. In fact, there was nothing west of 56th Avenue. This street curved. There was nothing back there. In fact, my dog used to go exploring in what is now the area where Hollywood Hills is.

"I liked Miami. I used to go to the nightclubs. Really. I went to the night clubs, and I would stand at the door. It always fascinated me to see guys play saxophones. I loved that. I just wanted

to see those guys play. I just lived for the day when I'd be big enough, old enough, to go in those clubs. We used to leave here; when I got big enough to drive, we'd go. Me and the girl I married. That's where we went, to Miami, Sir John Hotel, Mary Elizabeth Hotel. Now, these were all nightclubs, too, you see. And you had Café Society, although we didn't go [there] that much. Café Society was more for the elite blacks. You couldn't go there just any time. You had to be dressed, and you had to be of age. They would check ages. You always went west of the tracks. You never went close to the ocean.

"You always thought of Miami as the big dog. Overtown was the big dog. Everything else was a poor copy. Fort Lauderdale, I mean, it was nice, but as I became a teenager, I started to drive, and there were a lot of times we would go to Fort Lauderdale. You could go all the way up the coast. All black towns mirrored Overtown. I mean, you know, you could always find *us*. Now, they had those clubs, or those places, where [one] certain segment of the black community went, and there were those clubs or places that [another] certain segment of the black community went. They had their hierarchy. Miami was the big dog."

*C*yril Pinder Sr., who lives in a black community in Dania Beach, just north of Hollywood but intricately linked, was born in Miami and grew up in the Bahamas. He returned "home" in 1943 at the age of 21 to a troubling welcome: "One day after I came here, I never owned a wristwatch, you know. So [my aunt] told me how to catch the bus. It was myself and two other black individuals, two ladies, as far back as they can get. I put the dime in the meter, and I sit right across from the bus driver. So he took off, and every once in a while he glanced over at me, but I wasn't paying him too much attention. I was watching the scenery because it was all new to me. I was there about a week or two. So we got ready to stop, and a white man got on.

"[H]e stood up, holding onto the bar, looking down at me. I figured, this big bus with three people on the bus; if he wanted to stand up, well, that's his business. The bus didn't take off. The bus driver said, 'God, Nigger, get on up, and let that white man sit down.' I said, 'Do what? I paid a dime, just like him.' Excuse my expression. I said, 'Not a damn thing like it.' He said, 'Boy, I said get on up.' I said, 'Not a damn thing like it.' One of the ladies in the back, she said, 'Do, son, for God's sake, come to the back. Don't cause no trouble.' And when she spoke, she had a Bahamian accent. So I said, 'No, Ma'am. I paid a dime, just like him.' All these seats, and he wants this seat? I said, no. The guy asked me again, and I repeated what I said before. So he goes to his seat, and he had a bag hanging on the steering post, and he take his time. He untied it, and he comes out with a blue steel .38. And he comes to my face. I could see his trigger finger trembling on the trigger. So he says, 'Boy, I said get on up.' So I said the same thing. One of the ladies, she said, 'Son, don't make the man kill you.'

"I think he would have shot me, but I said, 'By God, before I go to the back, I'll get off.' So he said to me, he said, 'Do it and do it fast.' So I got off the bus, and I walked all the way back home, tears coming out of my eyes. My aunt . . . she said, what's the trouble? I said, well, I didn't know white folks treat black people this kind of way. I want to go back home. She said, 'Son, you can't go; you've got to go down to the draft board and register.'

"I had a friend of mine, he took me down there, and when I got down

19

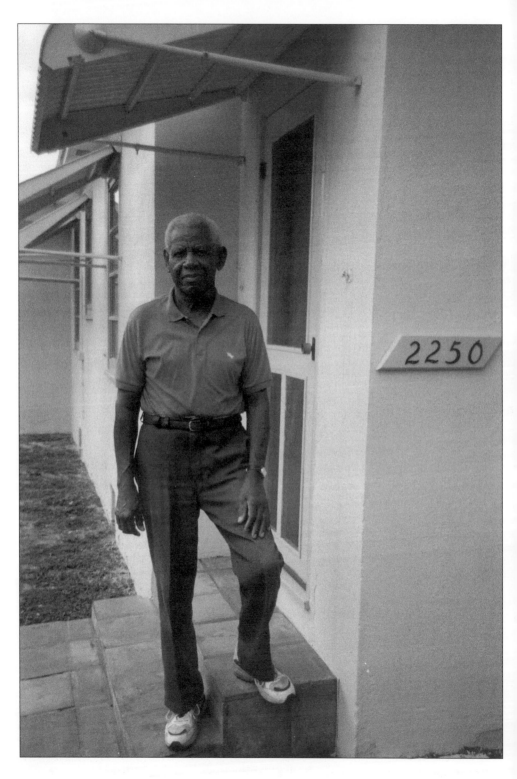

Cyril Pinder Sr.

there, the white man, he asked me my age, and he said to me, 'Nigger, you've been dodging the draft, huh? [W]here were you?' I said, 'Well, I was born here, sir, but I was raised in the Bahamas, and I just got back here about two weeks ago.' So he said, 'Well, I'm going to put your black so-and-so in Class I-A, and in five or six weeks, if you're any good physically, you're going to be gone.' So I said, Lord have mercy.

"I got on the bus and went to [camp], and on my way up there, I call them the 'American young men,' they were clowning, so the bus driver, he stopped over—I don't know whether it was, Live Oak, or one of those places up there— but he went inside the bus station, and he come out, and this man come out with a .45 on his side. [T]hey went to patting us down to see if we had any weapons or anything like that. So I said, Lord, what is this I done got myself into?

"My father's brother, and his sister, they were living in Miami. So they moved up . . . the road in Hollywood. [T]hey called it Liberia. So, anyway, she instructed me on how to catch the bus, and I caught the Greyhound bus, and I came up here. That's how I met my wife. [W]e walked from Dania, me and my wife, all the way to the courthouse in Fort Lauderdale. This was in '43.

"I was assigned to . . . a stevedoring outfit . . . I wrote my great aunt, who raised me in Nassau, and I was telling her about it. [S]he said, 'That's a life-time journey you done got yourself into . . . Grammy is going to pray for you that you won't lay your bones in foreign soil.' I was doing my work, you know . . . got a technical rating, and it made it much easier on me. And I went right from there. One time we went on an invasion, in the Philippines.

"[When] I was home from the service, got discharged, I told my wife, I said, I'm tired of sitting around. I need to find me something to do. So she used to do housework, you know, for the white folks. So she told me, she says, I saw down here on Taft Street three white men looked like they laying out a building. She said, maybe if you go down there Monday you might be able to get a job. I didn't have a car. I had a bicycle, and all the tools I had then was a saw, hammer, a square, and a nail apron. So I went down there, and I found the place. I leaned the bicycle up against the tree, and I went over to them. They were looking at the plans, you know, on the ground. So, I said, 'Good morning, sir.' They didn't pay me no attention, so I said good morning again. And they look up at me and he said, 'What you want, nigger? Well, nigger didn't bother me because in the Bahamas we wasn't accustomed to that word. And this guy,

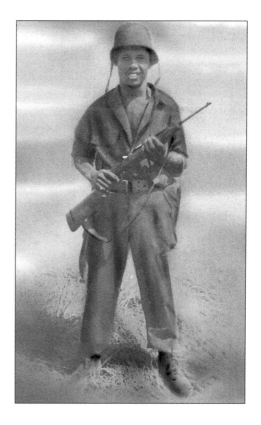

Cyril Pinder Sr., in the Philippines during World War II

he was a great big old fellow about 6 feet, and he weighed about 300 pounds. So I said, 'I'm looking for a job, sir.' So he said, 'What kind of work you do?' I said, 'I'm a carpenter,' and before I could get it out good, he said, 'Oh, hell, no. I can't hire a nigger carpenter.' So I said, well, let [me] dig the ditch. He didn't say anything, so I stayed around there, waiting until they get through.

"They laid the building out so they had the . . . boards and the lines all up for the foundation, and they went to lunch. They leave the shovel sticking in the ground. So I grabbed the shovel, and I went to digging. I said, I'm going to let these white folks see I know what building is all about. So when they come back, I dug down one side, and going across the back end. So the guy told me, when he come, he jumped out of the truck, he said . . . 'What you doing? Who hired you?' I said, 'Nobody. I just want you to see that I know what a building was all about.' I stayed there, you know, hoping that he would at least hire me as a laborer. Now, this was going on about 1:30. So I said, I was here since eight o'clock. Now if this man was going to hire me, he would have done hired me. So I got disgusted . . . and I got on my bicycle and I came home. That made me feel mighty bad. I said, Jesus, these people are something else. I done been and did my bit for this country, saying this is the state I was born in, and put my life on the line, and can't even get a job. So then I had to go washing—I had to get a dish-washing job for $30 a week.

"[Later] I joined a Carpenter's Union, in Miami. But they had white supervisors, you know, and black foremen. [Then] we had a Carpenter's Union here in Fort Lauderdale . . . so I moved my membership up here. The work was plentiful, but they would hire mostly whites. Like, if they building a school, or something like that, they would hire the blacks to do all the rough work, and then it comes to the smooth sailing, like finishing work, they laid us off and keep the whites. So . . . [eventually] we signed up with the white locals. That's how we got involved with them.

"[In the Bahamas] in school, if me and a white kid had a problem, the principal, he put us in the ring with gloves on, and then he settle it that way. And then, we shake hands. We still friends, you know. And where my mother was born, in Abaco—that's one of the Bahamian Islands—the majority of the people were white. But they all got along good."

CHAPTER 2

THE EARLY YEARS: MIGRATIONS AND MEMORIES

Separate worlds. That typified the 1930s, 1940s, and 1950s, when whites and blacks were aware of each other, but their contact was kept to a minimum. Attitudes ranged from resigned to fearful to unconcerned.

Robert Ryle, a 77-year-old electrician, was 13 when his family left Kentucky for Hollywood for a better life, just two weeks before the 1935 hurricane hit: "We lived in the hilly country there . . . in Kentucky across the river from Cincinnati, Ohio. Each winter, as the cold weather would come along, my father would get what they called . . . fever . . . they say that you get from unpasteurized cow's milk. He would be in bed most of the winter long from this fever. So the doctors told him it would be better for him if he went somewhere where the climate was warmer year round. So that's when, one summer, he came down here and liked it here for six or eight months. He went back home, put the farm up for sale, sold it, and moved down here in that year, '35. He carpentered down here. Then, after he quit carpentering, he went to selling real estate.

"It was a big deal to us kids, you know, moving off the farm to some place that we had never heard of or didn't know about or where it was. We were moved down here in a truck—a big panel truck in which you put a big tarpaulin over it and in which what furniture and stuff weren't sold or mother didn't want sold, [were] just crammed in there. Left a couch there for us kids to sit in. I forget how long it took us to get down here. It was an adventure and experience for us. But after we had been down here two weeks, we had a hurricane, and I was

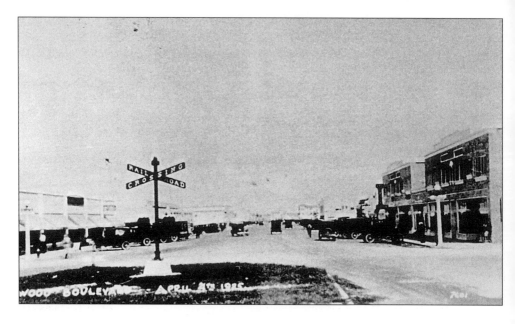

Hollywood Boulevard, 1925

ready to go back home then, back to Kentucky.

"There was an understanding that you didn't go in [black] sections. Had no business there, so I didn't go there. It was something I just didn't think about. It's like now, all of this anti-Semitism. Now me, as a greenhorn coming from a farm down to the town of Hollywood here, I look at a person, I just saw a white person. I don't know about the elders up there. There wasn't even any thinking about "Was he Jewish?' or 'Was he Polish?' because up there, such things weren't any focus of conversation. After I got older, I mean, I began to think more about the Italians, Jews, blacks, Hispanics, whatever. It was only then."

William Horvitz: "There were [black] areas outside of what I know of what Hollywood originally was, [like] Carver ranches. These were not in Hollywood whether they are now, I lost track. For example, the area around City Hall, surprisingly enough, had a large number of Italians living there. If you go back to big cities, they had ethnic neighborhoods. In Cleveland, where I came from, there was a Polish area, Italian area, etc. On a modified scale, there were ethnic areas. I don't think Hollywood had much. There was just an area where they had a lot of Italian people, but that didn't mean it excluded anybody else. I don't think we had ethnic neighborhoods as such.

"This was the South. [Blacks] couldn't be in the east part of town after a certain hour. But they got over that. It ended before or after I got there. You didn't know it, but it was the South. If a person was arrested, if he was black, they included that in the newspaper. At the courthouse, they had separate drinking fountains and restrooms. People don't believe it. The schools were segregated, and they were not equal. They were separate but not equal. It's the way things were. Should they have been that way? No. Rationally, people are people. But it was the way

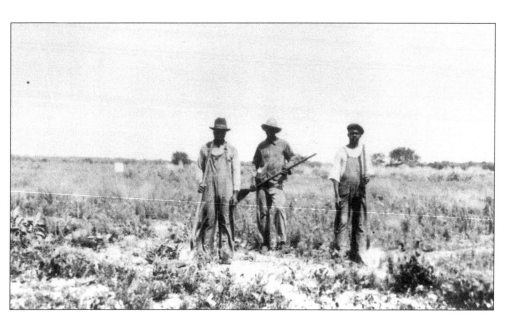

Black laborers helping clear land for roads

things had been since the founding of this country. The black community was not treated by the white community as equal, and some of the things that were done were just so unheard of, today. You're talking about politically correct things—they were terrible things.

"Some did domestic work. Others were laborers for construction. A lot of them were gardeners, where you had lawn services. We didn't have Puerto Ricans or Mexicans. The common labor was done by basically black people. They used to have, and I think they still do, [places] where people stand on the corner to be hired for that day to go do construction. There were no black people living in the white developments, at all. It just wasn't the case."

Gloria Hepburn Bridgewater remembers some of the personal indignities and fears that lurked while growing up black during segregation, and, later, working as a nurse's assistant: "You couldn't try on the clothing. And just like they do any black, they watch you like a hawk when you go in. They don't even give you a chance to decide what you want. They're like, 'Can I help you?' You know, like they want you to hurry up and get out. You know, get what you want and get out. You see, that's the way it was. And you sensed that wherever you went to shop.

"In the '60s, I remember, my husband—this is before he ran [unsuccessfully for city commission]—I can't remember what happened here, but one night, way down in the night, here come these two white men, and they knocked on the door. And they came and asked my husband certain questions, and I can't remember what it was, but they came and asked him did he know about it. And he told them, no, he didn't know anything. The reason why, I believe, [was] because he was so active in civic organizations, and he was a man interested in people. We were always fearful or concerned, but we were taught not to get involved in anything if it wasn't necessary for us

to be concerned about it. And we grew up that way, and that's the way Bahamians are. They do not rush into anything if they don't know what it's all about. That's the way I was reared, and that's the way he was reared.

"When he ran, they already had kind of subsided some of that high pitch on integration. He had many supporters, many from the whites, but he didn't win. At that time he was sick and worked at the hospital (where he was the first black orderly). He just wanted to see us rise up from where we were.

"I always felt like [white people] thought we weren't people. I never got too much involved with them. I worked closely with them, but I did what I had to do. I never associated. I never brought them in my house. I never visited them. I never get on the job, and talking—I never did that. I knew, in Memorial Hospital, when we went to lunch, they went in a different section, and we went in a different section. They got rooms set up, at that time, they had a room for the blacks to go in and have lunch, or break, and they had a room for the whites to go in and break and have lunch. But the only time we came together was on the floors because I was a nurse's assistant. They give us our orders, and what we had to do, and what we had not to do. And when I'm done with that, I'd go my way because I know that's the way the system was. But I never got involved. You know, some of us are real friendly and try to push. I never did, and I'm being honest and truthful. I kept away from them."

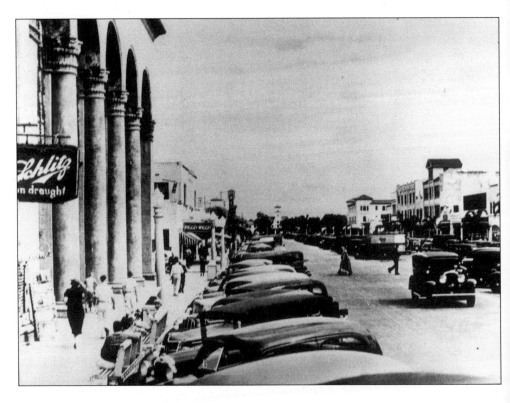

Hollywood Boulevard in the 1930s

Claude David Sr., 69, is a member of a prominent sports and political family that was among the pioneers during those early days in Hollywood: "I was raised during the Depression, and my dad owned a sundry store downtown, David's Place. I guess we were poor but didn't know it. My dad came here in 1925, when Joe Young had just started the city of Hollywood. He was a cotton broker, right north of Athens, and the boll weevil ran him out of Georgia. Young came in with his promotion of Hollywood and [my dad] got on a bus, and they came down here to see the land, and he bought a lot. With those old shell roads he said he remembered pushing that bus most of the way down here. Roads wasn't real good then.

"They said he planned things very well, Joe Young did. And he said he remembered that when they were building the house over on Polk Street, Mom came over and said that Mr. Young is downtown, he's allocating the stores; you better go down there and get a business. So he went down, and he allocated the drug store for him, and he got that one. Then he said that he didn't have anything to sell at first because transportation was bad and everything. He said he found a Nabisco cracker truck going down the street, so he hailed them down and bought all of their stock and put it out in the store. So that's what he first had to sell was crackers and cookies of all kinds.

"We mostly hung out on Dowdy Field right on Dixie Highway (at Johnson Street), always playing pickup baseball and football. We didn't have any gyms or anything, but it was all outdoor sports, and then we'd play around. The neighbor's kids had a vacant lot right there in front of a house, and we'd go over there and play baseball and softball and a little soccer. We didn't know much about soccer, but we just kicked

Activities in the 1940s at Dowdy Field

each other in the shins, mostly. We didn't have television or any of that stuff. Mostly they had softball games at Dowdy Field every night, and they'd have them signs right down Hollywood Boulevard saying, 'Come to Dowdy Field, Hollywood All-Stars are going to play Stuart Sailfish,' or something like that. So we spent most of the time at athletic fields, and then we'd go down to dad's store and hang around and get him to give us a little candy or something like that. [We'd] go to movies, of course, and did a lot of fishing over in the canals. Fished off the pier at the Hollywood Beach Hotel.

"They called it the Hollywood Beach Casino, which was a saltwater pool right there on Johnson Street . . . and we'd go there in the summertime. In the nighttime we'd go there and swim. They had like a program up 'til 9. You always go where the girls are.

"Mostly the built-up area was from U.S. 1 to Dixie Highway . . . The North and South lakes (east of U.S. 1) was nice houses and built up pretty good . . .

That area was built up all the way toward the beach, see, then you had the beach was built up. You had the little apartments. What they called Liberia was the black area, and it was along the railroad track north of Sheridan Street. It was still Hollywood. Of course, we lived right by the railroad too, but we were on up."

Joseph Young took the name Liberia from the new African nation comprised of many blacks who fled America. In an article in his newspaper, the Hollywood Reporter, *Young boldly outlined his "new town for Afro-Americans" as he called it, a mile west of the Florida East Coast Railroad tracks at Dixie Highway. It would be home to the servants and laborers. A large force of colored workmen would be employed to clear the land and lay streets and sidewalks for well-marked residential and business areas, and electric lights and water would be installed. A 5-acre Circle Park would be at its center. The community would be self-governing. Pioneer residents recall farm laborers living in a tent city and decades with outhouses, dirt roads, and streets without names. The municipal clout and the circle never appeared. Among longtime residents, however, a fierce loyalty remains.*

Marvin Merritt grew up in Liberia in the 1930s: "We had a unique community here. Everybody knew everybody, and we was mostly isolated from the white community. We had very little contact from the white community because we was self-contained. We had our own filling station; we had our own grocery store. We had everything, you know, for the community. We had our own churches. We didn't depend on very much. And as far as food was concerned, everybody here had chickens,

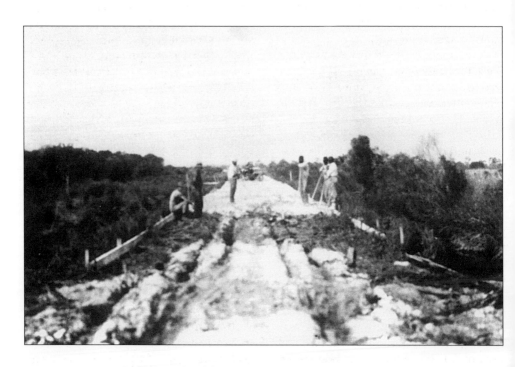

Laborers build a road in a new area, Liberia

and cows and, you know, in the Intracoastal—we had all kinds of fish down there. It wasn't contaminated like it is now; as a matter of fact, we learned how to swim down there. [T]hey didn't allow us to go to the beach back then. For the ones that worked on the beach, they was allowed to go, but they had a badge, and they had a man there on the bridge, that operated the bridge, and he would call their employers prior to them coming. And he would okay for them to come.

"[The] Hollywood Beach Hotel, I was here when they was building it. And at that time, they brought in a lot of foreigners and people from different places to work on that building. Over on Atlanta Street and Cody Street, they had a camp there that housed about 200 or 300 Bahamian people. And they also worked in the fields. See, we had a lot of farm land here—all the way from 24th Avenue, all the way back to the Intracoastal Waterway. [W]hen I left . . . I was about 14 or 15 . . . there wasn't no street signs or nothing. All the areas had names. See, everybody had a corner. [T]hey opened up that place down there they called the Silver Slipper. That was on Simms Street, and Sawyer's place. McKay's place was on Simms Street. That was supposed to be the red light district, like. Those streets were dedicated to be business. We had paths. We had no great roads . . . out in [what we called] 'the quarters.' You'd cut a path through the middle and go all the way up there to Attucks School. [T]hen you're 'up on the hill.' That's where all the Bahamians live, over 'on the hills,' because, in other words, they feel their houses are, like, on the higher ground. We would just build a house anywhere down 'in the quarters.' [T]hey had these houses that had a big porch, and you could go through the front and go right straight out the back. I can remember that real well.

"There was excitement, you know. We used to set traps and trap rabbits, and we would sell them for 15¢ a piece. We used to sell bottles for 30 a piece. See, along in then, you could go to the movies for 10¢. We were self-sufficient. On Saturdays, some of us would go to [downtown Hollywood Boulevard] and they had stores down there—Margaret Ann's and Piggly Wiggly. [But] we had Nathan's store along there near Taft Street in the black section, and later, we had King's store. There wasn't nothing to go [downtown] for. We had plenty of vegetables; we could raise our own chickens, and everything. We could cook up our coon, possums, and all that stuff. We had plenty to eat. That's one thing, we didn't have a problem eating. And the Bahamians, they did a lot of farming, too.

"As I said, they were dirt roads when I left, and when I come back, they were rock roads. When I came back here in 1961, I was about 31 years old. I stumped around. I worked on a race track. I was a self-raised person. You know, I raised myself. See, my mother died when I was nine years old, and I didn't have no mother or father. I had nobody. I had my grandparents, and they didn't know, what I might say, the importance of having an education. You understand, they thought that when you could read and write, that's all you need. I cooked for the Union News Company in Jacksonville first. [T]hey was an organization that owned restaurants in the bus stations, in the airports, and stuff like that. I worked for Fort Lauderdale/Hollywood International Airport. I worked the [Hollywood] strip a long time, too, down on the beach around '64.

"I was the first black cook that ever cooked in the Hollywood Beach Hotel. All they had was stewards. But, boy, they really give me a hard time, you hear me. I went to the employment office

to see about a job, and when I got there I carried my resume with me. He said, 'You can cook?' I said, 'Yeah.' He said, 'I don't know whether you can handle it or not.' So he had to call the executive chef at the hotel. [He] said, 'We never hired no colored cook here.' [But] he was hurting. So I helped him through lunch, and they put me in the hottest part. Boy, let me tell you something. Them people say, 'You coming back?' They were hugging and kissing me. He never wanted to hire me, see. So then he finally agreed to go ahead and hire me. I stayed there for about eight years.

The hotel, that was real uncomfortable for me. There were no blacks in the kitchen. I was the only one. All I remember were Spanish, and I couldn't speak Spanish. I learned a little.

"I always felt like a foreigner in this country. I never felt like I belonged here. I guess back into early history, how they would talk to black people and how they would treat black people. It's not quite like that [now], but a lot of bigotry and hate still exists here. When they dug my family up out there in that graveyard, I thought about that quite often. Where they dug them up at,

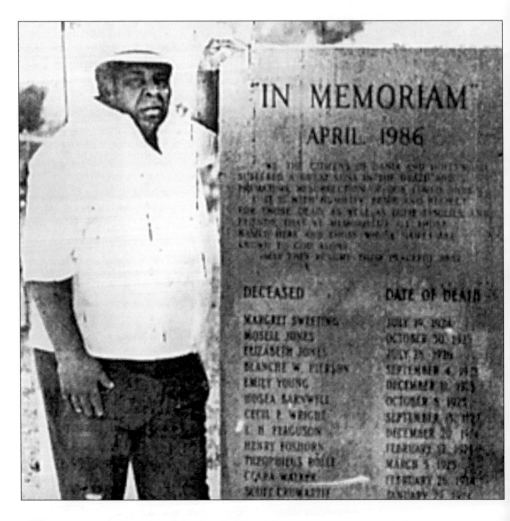

Marvin Merritt (left) with cemetery memorial

the stones are still piled up out there. They had black people burying them across the railroad, to (white) Woodlawn Cemetery. They buried them in that corner. And when they decided they was going to create a black cemetery, then they dug them all up. The blacks got the privilege to come out there and dig them up. I was a little boy, and I used to go to the fence and watch them, watch the prisoners. That was back in '38. They put them in boxes, and criminals were even getting their gold teeth. Along in there, years ago when you died, you buried everything with you. You buried your medication, and they have a little box, like a shoe box, that they put in the coffin with you. And when they dug them up and desecrated the graves, they got a lot of stuff there. We got more respect, [now]. People are more respected than they were back then. [But] I never felt like I was ever home here."

Bahamian culture permeates Liberia. Bahamian workers had been coming to Broward County as early as the 1890s in the Fort Lauderdale area. Many came to Hollywood from Miami, luring other family members and creating a close network of kin. Others emigrated directly from the Bahamas.

Dorothy McIntyre belongs to one such family, although she was born and raised in Liberia: "We didn't know we were poor until we got grown. We had a fairly decent life. My mother was home; she took care of us. And we didn't realize what a difference it was during that time when we were little. As we grew, we realized the difference. Some people thought they were better, but we adjusted and had a fairly decent life. My father owned a bicycle shop right here many years ago, and he rent to all colors [and] races, and so we had quite a few people coming over from Hallandale to Fort Lauderdale renting the bicycles on Sunday afternoons because there weren't many cars then.

"[H]e had the bicycle shop, and he was in construction. My grandfather had a little neighborhood farm, [and] Papa had a farm. He had people to work for him, but we'd go up and work with him on the weekends, and we always used to have tomato fights. I think I have been very blessed with the kind of life my mother and father provided for us. Things were hard during that time. I remember, you could get a loaf of bread for 5¢, or you could go and get enough pork chops or beef stew to feed the family for $1. [T]here was a friction. Sometimes the boys would get together, the gang from Dania want to fight the Liberia boys. The children, they used to get together and go out there and play baseball, or softball, and football. But it was, like, Dania against Hollywood. But that was all black.

"We had a lot to eat. And then, my mother was a baker. She made bread. When we baked bread, it's not for us, it's for the neighbor. You'd have to get on your bicycle, go in the neighborhood, and deliver bread because Sister Edna's made bread. If you were sick, or you have a baby, you could rest assured a pot of pea soup and a loaf of bread is coming to your house. People cared about each other. This was before we got barged in with all the apartments and people from everywhere. You could walk from here to Hallandale, or walk from here to Fort Lauderdale. I remember many days my mother went out—where the Jai Alai is, now, in Dania—and came back carrying a whole thing of bananas on her head. Because you didn't have cars, they walked. And nobody bothered them. One time, some young white guys started bothering with some gentlemen walking—

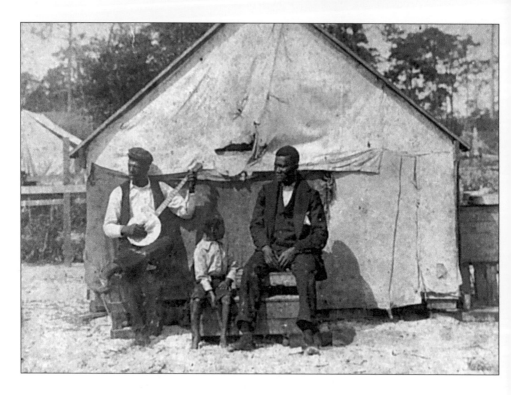

Bahamian workers in Broward County, c. 1890s

I think they were going to church in Hallandale—and they came and talked with my father. My father was one of the persons who was the officiator of the first black Chamber of Commerce here, and he was respected. They got the group together, and they went to [the chief of police]. I don't think that happened any more.

"[In the] '40s–'50, it was changing. [Y]ou didn't go over there bothering them women, and we didn't want them bothering us. It was like an understanding. But there were the younger ones, coming from all over, and I think this is when you started realizing there was a big difference in races. Now, I wasn't blind. I knew you were white, and you knew I was black, but we had a little respect for each other until this, like, what you call the new breed I think my dad called it, came in. And they were starting it.

"[Y]ou didn't realize it was a problem because you tend to your business, and they took care of theirs. And all of a sudden, you could be walking, minding your own business, until these young ones would come up on their daddy's truck or something and start jeering and picking at you. [After the war], everybody was coming.

"There was a store called Henry's Shoe Store, down in Hollywood, near the track, and we used to go there and get our shoes. We would go in, but you couldn't sit where Ms. Jones' family sits. They had a place aside for black people, but they did it respectfully. They were killing us with kindness, and we didn't know it. We would have to sit on this side, and they'd take care of them first. But, like I said, my parents were, you know, different. When [a store] got new things in, they would call my mother to let us know.

A military parade in the 1940s on Hollywood Boulevard

And we could go in, but we couldn't try them on. We brought them home and tried them on, and if they didn't fit, Mama would take them back and get what we needed—which was stupid. We could have done anything to the clothes. Anybody could have. Just to say, to keep us apart. They thought they were keeping us apart. Sears brought on a change in the '50s because they treated us better than the other little stores.

"When my grandparents came over, my mother was a little girl. She was born in the Bahamas and was partially raised in Miami; then they moved to West Palm Beach. My father was over here on something that's called 'la contract.' The fellows came from the Bahamas to work the orange fields and things up in Orlando and all that area, many years ago, and he met my mother and they fell in love and got married. They worked in the orange groves, and McArthur's Dairy. I have orange and grapefruit trees in my yard from when they planted it when I was a little girl. But they used to go up on the west coast, and they'd pick oranges. They had the hog farms, McArthur, and some orange groves out there.

"I attended Attucks High School, elementary all the way through high school. When I started in high school, I worked some. I did work occasionally. What happened, some people in the city of Hollywood had families come up, and they needed someone to babysit their children. After school, we had a few minutes to do our homework, and with our parents' permission, we went and we babysat their children while they went to whatever, but we had to be home by nine o'clock. Everyone couldn't do it. You had to be from a specific family. They wanted the best of us. You know how people are with their children, like we are with ours today. [M]y mother and father were very strict.

A student at Attucks School

They had to meet the people I was working for, and there were certain things we didn't do, because there were smokers and drinkers. We didn't have any of that . . . my parents, and a few others, would not permit that. And we did that until I graduated from high school.

"I wasn't afraid because I have a father who didn't play around, and he knew everybody in the city of Hollywood, so we were treated with respect. We were treated with respect, because if I come home and I didn't like anything, they would report it to Professor [Joseph] Ely, and that would be it. It was like family caring about family because, if your daughter had a problem, we will discuss it, and we wouldn't deal with that family any more. I didn't think I was poor, but we were very well protected and not abused in any way. [D]uring that time, girls stayed home and had babies. And I think they thought they were preparing us for that—that part of our lives– because we took care of these people's children. But then, after the tide changed, you know, we don't have to stay home and be the babysitters any more.

"We learned how to fill out applications in school along with how to approach people, how to dress, and how to talk to people, which was very good. And, like I said, this followed me through until my adult life. [When I started working in the '50s] when you walk in, they look at you from head to foot, and kind of in a disgusting look. When I approached them, in the back of my mind, as today, I remember what Professor Ely said. I think he knew there were changes coming, the way he taught us to speak to people. He could have said, like, you know, you're going to stay here, you're not going to college. But he prepared us. He showed us how to do things. Professor Ely, he was the head, but we had several good teachers who cared about you.

"I was at these people's house and taking care of the children. It was two boys, and he wanted to do something, and I wouldn't let him do it. And he called me a nigger. And I didn't say anything right then. But when his mother came back, I said, 'I told Wayne to do whatever it was, and he called me a name.' I said, 'I treated him nice.' She was very upset about it. That was my first time, and I was in high school then. [W]hen we came back to the school, I think we were talking. They had an open discussion, and that's when they got the dictionary—they handed me the dictionary and showed me the word. We called each other that all the time, but that was the first time I knew, really, what it meant. I'll always remember that. His mother made him apologize. But I did take that back to a group—we had, like, a prayer group, or whatever, at school. And we discussed things like that. I told them, I knew I wasn't a nigger. I was whatever; I was colored because the word colored was the word we used when I was little, not black.

"After I finished high school, I did some motel work, dealing with other people, but I had, you know, a good personality. Professor Ely always taught us, look them in the eye, anyone, and say what you feel in your heart, and you wouldn't go wrong. And that's what I was basically raised on. I don't care who it is, I will look you in the eyes and tell you in a nice way just how I feel. These were some of the things that were instilled in us as children. You may be black; you may be poor, but you have pride, which is very good. And that's what I instilled in mine. I had the opportunity to go to college. In fact, I had registered for Grady's Nursing School, but a gentleman came by and caught my eye and my heart, and we were married for about 40 years

until the Lord took him away about eight years ago. Even after I got married, he wanted me to go back to school, but I didn't. In a way, it wasn't meant to be. This is the home where my mother and father were, and being the oldest daughter, I stayed home to take care of mother and father.

"[D]uring that time, Hollywood wasn't hiring blacks. The white people owned the beaches and the hotels in Hollywood, basically, and they didn't want to see us. The only people they hired in Hollywood for motel work [was] the black men who carried the heavy luggage. All the maids in there were white, basically white maids. But the ones in Hallandale [which] the foreigners owned, they hired us. Colombians, these were people that was immigrating here, who brought their money with them. [T]here was a whole string of them. It was like they were a group. I became a housekeeper, being responsible for some of the duties with the maids, and then, after a couple of years, I think they saw what I could do, and they had a couple of white maids come in, and I was their supervisor. I worked my way up."

*E*dna Bain Symonette's home was also a center of activity in Liberia when she was growing up, and she remembers many of the details of daily life well: "The story [my father] told me was his mother, they used to come to do farm work and whatever kind of work they could find. His father was a boat captain, and he went from island to island, from place to place, and my grandmother, I understand, she and two of her children drown over the '26 hurricane, over in the Belle Glade area.

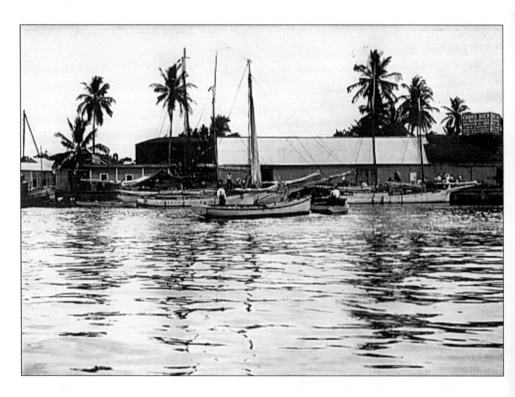

Bahamians arrive by boat into Miami before moving on to Hollywood

My dad came to this country when he was five years old. An uncle brought him over. He was just, like, a jack-of-all-trades in this neighborhood. He did plumbing; he did electrical work; he did mechanical work. But the last 40 or 45 years of his life, he worked on a dairy farm. He milked cows—he helped do that, and then he was maybe in charge of all the other hands that were working. He used to pick them up in the mornings and bring them to work, and they all had different duties to do. As a kid, we used to all go there and horseback ride. He used to always take us out there to ride the horses and, you know, experience them milking the cows and what not. Even on Cody Street, where I was born, we used to have a cow there. I'd milk cows, me and my brother. My dad raised chickens, and he had a hog farm. That was back in the '40s.

"My dad would have a big truck, and he would come through in the morning and transport [contract workers] to the different farmers up to Pompano and the Deerfield area. They worked in the fields all day and come home at night. I did that, too, during the summer months. We did that to make extra money for school, and buy school supplies, and stuff like that. I had some playmates; they used to go up every summer to the fields in New Jersey, or in New York, to work. When the crop was over, whenever it was over, they came back, and school was already, maybe, like three or four months started.

"When we had a hurricane, my dad would always go on every street in this neighborhood, and he made sure that everybody's house was boarded up, and if they needed help, he did it. Even during the hurricane, he would leave the house and go across the street to the elderly people who didn't leave because they didn't have shelters or things to go to, nothing like that. He would go over and make sure they was all right.

He would get out and wander in that hurricane to make sure everybody in the neighborhood was safe. If they needed to leave, they would come to our house. And most of the time, families used to always get together in one place, anyway, if they sure their house wasn't safe.

"My dad always brought milk home from the dairy—two of these big kegs of milk. And every afternoon he come in, he would put them in the bottles, and me and my brother was down this road to everybody's house taking the So-and-So's some milk. When he was farming, he always bring extra vegetables home, and me and my brothers used to cry because we wanted to play, but we had to go take these things to our neighbors. That's what he made us do. We had a lot of fruit like guavas, mangos, coconut, oranges—everybody had a little something in the yard, or the farmers did.

"My dad had an old flatbed truck, and if someone else need to use it, he would just let them borrow the truck and go whatever, or take them wherever. There were very, very few cars. The buses came along in, I guess, late '50s I imagine, if my memory serves me right. At the time, I think the name was Springer Bus Service they had, and I think Broward Transit bought him out. He had a taxi service, too.

"We didn't have inside plumbing. Growing up down, right here on Greene Street—Greene Street and 23rd where my grandmother's house was, in fact—everybody in this neighborhood had outhouses. That's when they had the wood stoves, no electric light. There was oil lamps. No running water. We all had the hand pumps. I did that many days for my grandmother to wash. We had to just—me and my cousins—we all had to go down there and pump three tubs of water, one to wash, one to rinse, and one to do the other. It was hard, hard work, those days. Really hard.

Starlight singers, Attucks School, c. 1952, featuring Edna Bain (front row, far right) and Helen Franks (standing, far right)

When the plumbing did come, I think the bathtubs were in, but they didn't have a toilet. You still had to go outside. And once—it might have been when I was very, very young—they didn't have any plumbing in the house at all. We bathed in one of those tin wash tubs in the kitchen. We did all our washing of our dishes, and everything was done outside. And my grandmother had the pot belly stoves they talk about.

"[There were] very few radios. Just maybe one or two families had a radio and, man, that was a big deal. I remember when Joe Lewis was the heavyweight champion. He was the big well-known boxer. When the fight would come on, me and my dad and my brothers, we would go down to Mr. Sam's home. He's the only one that had the radio. We used to have to go down and listen to the fight on the radio. It was a big thing. He was black, and that was good news to hear he won. Yes.

"My dad, he was really a people person. He seemed to get along well with the white folk. As a matter of fact, we had a black Chamber of Commerce here. It was right down the street here, right in this block, on Atlanta Street. The property is vacant right now, and they got a little small building there. It was in the '50s, and he was the president of the chamber. His name was Arthur Bain. Most of the people that was involved have all passed on now. He used to always go down there and talk to the people at the city hall about bettering this community here. I remember one thing they was trying to do. They was trying to get some blacks to work on the garbage trucks. My dad went down, and that's one thing he wanted to get, some black men to work on the garbage trucks, and they wouldn't allow it. In the morning time, we always had to get up and put our garbage cans at the roadside for the trucks to come by and pick it up, so when my dad went down and asked them to put blacks on, to work for the city, they wouldn't allow it. So then he told them if they didn't do that, they would have to come to the back door to pick it up. So they started that at that time. They just go right to your back door and carry the garbage away. We didn't have to carry it [to] the curbside no more. That's one thing I remember. But I never was involved in the meetings and stuff like that. I know, once, we had to have shots for something for school, and he went to the county, and they sent a mobile unit out here for all the kids to have shots. It sat right up at the Chamber of Commerce right down here. He got that mobile unit to come out, and all the kids and families signed up.

"We always had a parade early Christmas morning. The Community Band—everybody played, and we kids, we had to go to bed early, and when we heard that band strike up in the morning, everybody was out on the street. It was so nice. Everybody really enjoyed that. It was maybe about 15 people, because just about most of the people from the islands all could play instruments, even if it's just the bongo drums. They played for funerals. We always had funerals with the hearse and the band and the family. See, this community was mostly of Bahamian descent—Bahamians, or migrant people from the Bahamas—and that was a way of life for them in the Bahamas, and they just did the same thing here. When they had funerals, the body never went to the church. It always went to the home. They sat and had a wake with the body all night. Then, next day, they have the funeral procession and marching. I think they still do that in the Bahamas today.

"My mom, she did domestic work, different homes. She cooked. The family she worked for over there, they were real nice people. He was from Alabama.

We ate just really the same things. It wasn't nothing like most people say—that white people eat this and black people eat this. They were just from the country; he was a country guy. He ate cornbread; he ate greens and everything we ate. So it was very easy working in that home.

"I got married right out of high school. I wasn't planning on going to college or anything, and when you get 18 years old, you sort of start out making it on your own. Someone came in my life, and we just got married, and I stayed home because shortly after I got married I got pregnant with my oldest son. But I was married just for a short time because my husband died at the age of—he was, like, 30 years old—and I never remarried. I started to work—at first working at the motels and domestic work. [W]ork was almost like a word-of-mouth thing. If this lady had someone working, they always would call us girls [to ask] if you know a gal, or girl, that I could get to work for me. I worked for this family a couple of days, maybe, and maybe down the street they used me for a couple of days. They gave you a lunch, but you never could go in their dining area to eat. You always had to eat, like, in the kitchen. You had to come in the back door, and that's the way you left. You just didn't have one special thing—you do the cleaning, you did the cooking, and you had to babysit if they had a young child at home. You did all that in an eight-hour day from eight to five, or from nine. You worked an eight-hour day, like that. Then I decided I would go to school, and I went to Sheridan Vocational and took up nurse assistant. I'm sort of semi-retired right now.

"When I was in high school in the '50s, we had our school material—we always got the used books, you know. I didn't know they were. I thought that was the way they was. We wasn't told they were used. Half of the pages were out. They had other children's names written in them. That's when I started hearing about [integration]. We was all whispering about what school we was going to go to. Some was going to stay here; some was going to go to South Broward, and you know, they was going to split us up when it was going to be integrated. We was saying this portion of the kids in Dania was going to go to South Broward, and we were going to stay here at Attucks. You know, we was just talking among ourselves, what we thought was going to happen when we first heard about it. This was around about [1954].

"[D]owntown, for instance, you had to use the restroom; you had to go to the filling station, service station, the train station, or the bus station because they was public places. And they still had 'colored' on one door, and 'white' on the other. The fountains was the same. I had a friend of mine, she had an uncle that worked downtown at an ice-cream parlor, and if we wanted to use the bathroom, he would allow us. But if we just went in and asked someone else, they wouldn't. Up until the '50s, sometimes you would go in the store to purchase something, and they would always say it was out of order. I had a friend of mine that said, 'Well, where do you go during the day if you have to use the bathroom?' Never got an answer.

"The beach, that's another thing. When my dad was with the chamber, we wasn't allowed to go on Dania Beach, Hollywood Beach, or any beaches. Most of the time, we had to go down to Miami at the colored beach, Virginia Key Beach. We all had to leave early in the morning and pack up and go to Virginia Key Beach. So when my Dad was working at the chamber, him and the men I told you about before, they went to the county, and that's when they said they would allow us to go to the beach [now John Lloyd State Park] on

Blacks on a segregated beach

holidays—the 4th of July, Memorial Day. That's the only time we was allowed. Then they had to get a permit from the county. They didn't have the road. We would all get a truck or however, go over to the intracoastal, and catch a ferry to go across. That was back in the '50s [and] up until in the '60s. This ferry went all day long, back and forth. All it did was transport people all day. I guess we were somewhere up near [Port Everglades]. This big ferry would come up, and you got your barbecue grill, your babies, the children, the cribs, and everything. And we went over there and spent the day. The mosquitos were so bad, but we just went over there and enjoyed it. That's the only time we was allowed until the Civil Rights [Movement], and they could get the road in. Then you were allowed to go.

"The only black doctor I knew was in Fort Lauderdale, Dr. [James] Sistrunk [at Provident Hospital]. Now they're able to go to the hospitals and stuff like that. During that time, you know, most children were born at home with midwives. I was born at home. My brothers, the three of us was born at home. My youngest sisters and brothers was born at the hospital. That's a change over from that."

Helen Franks, 67, friend and neighbor, is also of Bahamian descent. She was born in Liberia, and still lives there: "It was always like a family community. If they killed a pig, everybody got a part of it; whatever we raise, everybody shared in it. We always had plenty of vegetables because [my mother] farmed. On Christmas, when everybody

the trombone, he played everything. I came from a large family. My parents had nine children, but we were happy.

"Almost all the men was very skillful as far as building. Everybody in here—my father and his friends built our home what burned down, maybe, in '75. But most of the homes were built by men in here. They were very skillful, and they helped each other. He was from the Bahamas, Andros. And he came here as a child. They settled in Charleston, South Carolina, and then they came to Miami, he and my mother. Of course, my mother was brought straight from the Bahamas into Miami. [She] came as a child, like seven years old, and her mother brought them over so they could have a better life. She brought her three kids here as little kids and left them with relatives or somewhere to work, and they never went back. That whole idea of leaving the island, leaving one of the islands and coming over here, was just that there were work opportunities regardless of what it was.

Helen Saunders Franks (right) and her sister, Regina Adderly, on a colored beach, 1963

"My mother always had a farm, and we raised chickens and ducks. So we had chicken, we had spare ribs had eggs all the time, and cabbage, or stew beef because we were tired of potatoes, beans—everything. We always chicken. And ducks. Mom always had had our own farm. A part of it was at the fish, and she would fry some of it, and house, and the other part was just west my dad would make stew and put of Attucks, where Attucks is, because dumplings in it. Everybody, on Saturday, there was nothing there. All this area when they knew he was cooking that was farm area. And it wasn't owned by pot, they came and ate. anybody that we knew of, so you farmed

"My mother was Methodist, and my wherever you wanted to. If somebody father was Episcopalian, so we went to was sick, you didn't have to know them church at the Methodist in the morning, personally; you just went and [helped]. and in the afternoon, we went to I remember growing up, as a child; I Episcopal. That tells you how our life knew everybody that lived here. I could was, full of church. And New Jerusalem tell you who lived from Sheridan Street was the only Baptist church here. We all the way back up to Attucks. I knew didn't have a lot, but I always remem- everybody. And it's just since all the ber, we had our own home. And my apartments came in, and people began father was a musician, and he taught coming in that, you know, you've lost music to many of the kids from Dania, that. If my clothes were on the line the ones who could afford it. It couldn't and it started raining, it was nothing for have been more than 25¢. The trumpet, a neighbor to come and pick them in

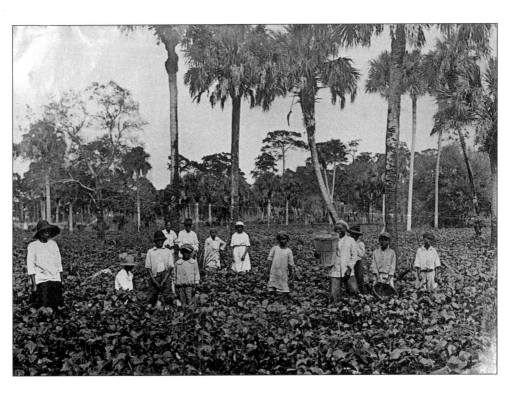

Blacks doing farm work in the 1930s

and put them in your house. Because we didn't lock our doors. There was no need to. So everybody was like one big family.

"The Evans had a restaurant there on Hood Street, just a couple blocks down. They had the only telephone in this neighborhood for a long time. Any time you wanted to make a phone call, you had to go down there. He was always very nice. Even if the restaurant was closed, and you had an emergency, he would open up so you could go in and make a phone call. We had to go to Hollywood to get our mail, through general delivery, because there were no streets. They hadn't even named these streets, I don't think, in this community. Or was it like that all over Hollywood? Every day after school, I had to walk to the post office. I think it was further west at one time, maybe on Hollywood Boulevard.

"In later years, [at] the King Grocery . . . they sold chicken feed, you know, because everybody had chickens. They sold the feed out then you bought the fabric, and it was beautiful fabric. That's what we used to make clothes out of. Annie Thomas used to own [a hair salon]—and Ms. McKay. It was mostly, I guess, within their home. And they had the barber shop down there, and a little barbecue pit over there—Otis' Barbeque. And one time, they had a grocery store, Harry's Grocery Store, across from King's. That was run by a white man, Harry's. He didn't stay here long.

"It's always been very segregated. We didn't come in contact with many white people. We didn't go to school together. There was nowhere you went with them. I never knew any white kids my age."

Claude David

Claude David: "We'd go down to Dowdy Field, and we'd play with the blacks there, and they were pretty good athletes. They were pretty tough. We had a lot of fun with them. I played; I went to college at the University of Florida on a football scholarship—got a degree in physical education—and I never played against a black. My brother Sam was an all-American at the University of Miami, and he played against the University of Pittsburgh, and they had a few blacks and a couple of universities had 'em. But when they came down here, they didn't ever bring their black athletes because they wouldn't let 'em in the hotels in that era. I remember at the store, downtown, they had a white fountain and a black fountain, and a black bathroom and a white bathroom that always seemed kind of strange to me.

"When I was growing up in the '30s and '40s, [Hollywood] was just a tourist-type of community. We had, maybe, 3,000 people year round, and maybe 20,000 to 25,000 in the winter. During the war we had about 20,000 Navy personnel. The Hollywood Beach Hotel was a Naval navigation school, and what is now Presidential Circle, that was the Riverside Military Academy. We had a Naval gunnery school there. [Fort Lauderdale/Hollywood International Airport] was a torpedo bomber and dive bomber base. It was all owned by the government. And the Coast Guard, they were on Hollywood Beach on horseback. That was when the Germans had spies here. They caught about six spies that just landed from U-boats right here in Hollywood, in this area.

"I remember one time . . . [a friend and I] had gone camping out in Dania Sound in that little Whiskey Creek area, and we were sleeping there at night, and when the tide came out and in the morning there was this awful noise out there. So the tide was out, and we waded across the creek, and we saw a zeppelin. They had evidently spotted a submarine, and the submarine surfaced and started firing at the zeppelin, and he called into the Fort Lauderdale Naval Base and they came out . . . it was like a movie, you know . . . really exciting for us, but scary, too, you know, for a 12/13-year-old kid.

"I went to Hollywood Central till the sixth or seventh grade, and then I moved and went up there to [the old South Broward High in] Dania because I wanted to play football. It was a large T-shaped building at the time, and it was real small. We had about 600 to 700 students in the whole thing, and the elementary grades were in the lower part, you know, on the first floor, and the high school was on the second floor. It went first through 12th."

Helen Franks: "Our school [Attucks] was totally black. There was five and six grades in one room. We never had a new book. All of our text books were hand-me-downs from the other schools. And we couldn't attend another school. This school, Attucks Middle School, which it's called now, took care of all the residents from Dania all the way to West Hollywood and Hallandale. And there was no bus—they had to walk, or pay for their own transportation.

"[I credit] Professor [Joseph] Ely with instilling a lot of self-esteem in all the students, and really teaching us what's important. He suffered a lot because he wasn't given the opportunity with new books and the tools that he needed to make it a better school. He endured a lot. When I finished, it only went to 11th grade, and I wasn't really going to 12th, but he insisted that I come, and he told me that he would get a bus to take me to Dillard. At first, I had to pay. That helped more students to go

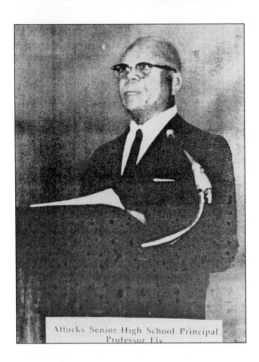

Professor Joseph Ely

and finish high school before Attucks became a senior high school. When my sister came out, in the '30s, it only went to 9th grade. So every year he, you know, tried to add on, and he did things slowly, but he never neglected the students there. He knew everybody. He knew my whole family. And he could call—and even after we finished school and we met him, he knew exactly who we were. And he was a great person.

"The superintendent came there one day, and it was pouring rain. Professor Ely went out to the car, and we thought he should have sat in the car with him and not get wet, but he stood outside and talked to the superintendent while it was pouring rain and got soaking wet. We thought it was funny, but I guess he just wanted to show his respect to him. So he endured a lot to make it easier for the people today. [He was called] Uncle Tom because he would seem to give them—give the superintendents such good respect when they wasn't doing anything for the school. He still highly respected them, you know. But, I guess that's the way of showing the students that, regardless of whatever people do to you, don't let it stop you from making it big. And most of the students left there and went on to college and, you know, did well."

Claude David: "I remember when I was a kid, after sundown you couldn't see a black in the city of Hollywood. If they were working in a hotel or something, they had to have a written slip or permit or something or the chief of police would question [them]. That was the story you always heard. When my mother would have a maid come home and help she would always drive her home after dark just to make sure she didn't get in any trouble for no reason.

"My brother Sam, he told me about the one time he saw a hanging [in the area] where they said that this guy raped a girl or something. I never saw it personally, but he told me that. He's older than me—he's about 73 or 74. He said they'd put the pennies on his eyes after they'd hung him and all that stuff—he didn't even know what that meant. Dead man's eyes, I guess. That's the only thing . . . We'd have the usual skirmishes with (black) kids like you do in different neighborhoods, but nothing that I remember as being racial."

Helen Franks: "We weren't allowed to go to any places where the white people went. If we went to an eating place, we had to got to the back door and stand up to be served. When the buses started running here, we were only permitted to sit on the back seat, whether the other seats were empty or not. They didn't have [black] cashiers anywhere, or sales persons.

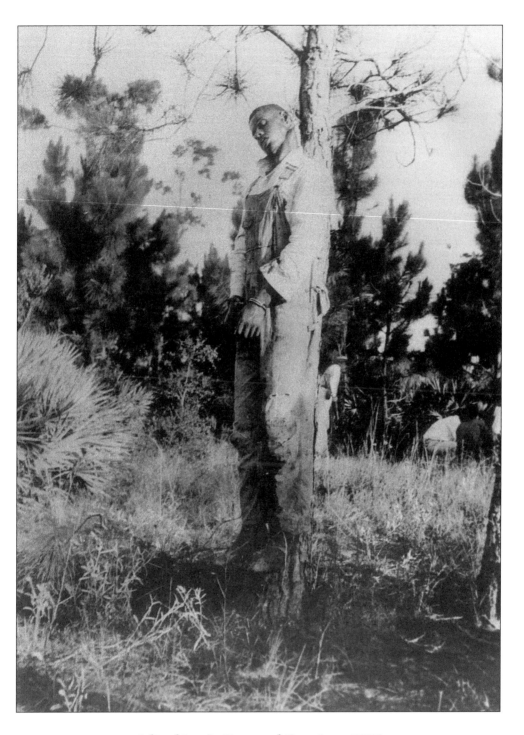

A lynching in Broward County, c. 1935

You were able to maybe get jobs, but you always—even at 13, I remember that I used to take my sisters to work at the hotel, and I would do the laundry. [T]hen I'd walk downtown, and I got a job working in an apartment house for three ladies, and I would make $3 a day, you know, with each one, cleaning the apartment. But that was basically all. And then, in '48, I worked doing laundry after school, at night. They had a laundry on Hollywood Boulevard.

"After I became an adult, I remember working for a dentist at his home, and the dentist he worked for didn't accept blacks. I asked his wife one day, because she was so nice, I said, 'Does your husband take black patients?' And she said, 'Oh, Helen, I don't know, but I would ask him.' But she didn't tell me any more. I guess she knew that he didn't. But when he opened his office, he had one waiting room. He opened it up to everybody. And my sister even got a chance to work as a technician in his office. This is in, maybe the late '50s or '60s. But before, in a doctor's waiting room, you had to go in the back, and there was just a little cubby hole. And most of them didn't take black patients. There was only one dentist between here and Hallandale that took blacks.

"Things have changed because now you could buy homes anywhere. And I don't think we did it. You know who did it? The Haitians and the Jamaicans. They were more aggressive than the American blacks, and they integrated the city. Hollywood was one of the last places to integrate. [T]hat's why a lot of the people here have moved to different cities. It was always so much more expensive to have a home built, or to buy a home, so everybody moved away, where they were able to get homes. But somehow, the ones who stayed, you know, this is where their roots are."

Cathleen Anderson has deep roots in Broward County. She was born in Pompano Beach, north of Fort Lauderdale, and six generations of her family have lived in the area. She moved to Hollywood in 1956 and has been a longtime city commissioner: "We always had a black lady to help my grandmother since I was a child. My grandmother was elderly, and she was helping to raise my sister Clara, my cousins; my uncle was drafted into the Army, and she was helping raise his children. Genie used to come to our house about two days a week. My grandmother had a stroke, and she was unable to do everything herself, so Genie was a part of our family. We had a big time when Genie came. We'd wait for Genie in the morning because in the cold weather [she] would bring a special kind of sweet potato, and she'd cook it. My mother and aunt would take care of my grandmother at night, and Genie would take care of her in the day and Genie . . . her children were grown and her husband could take care of himself, and she stayed with us and she would sleep in our house. [I]n 1950 you had to tell the police department if a black person was staying at your house overnight. [T]hey forgot to do it, and the police came by and said, 'We understand that Genie is staying here,' and my aunt said, 'Yes.' She brought him in, and he saw my grandmother who was in a coma. I don't know if that was a law or what, but I was always aware.

"[There was] a little girl who was in the home school [with my mother]. My grandmother used to teach her children how to read. There was no such thing as kindergarten. This little black girl lived west. See, in Pompano, most of the black residences were west of Dixie Highway. And as I said, my grandmother lived on Dixie Highway. In fact, my grandmother used to make a couple of dresses for her when she made dresses

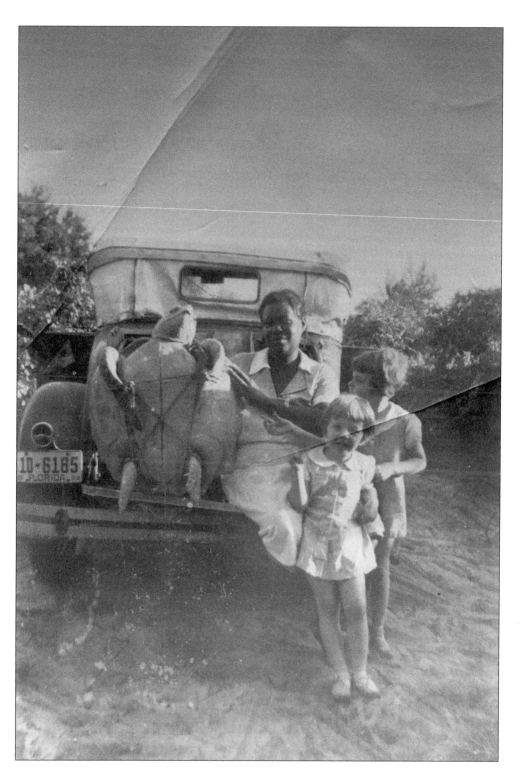

Cathleen Anderson, her sister, and Genie Stuart

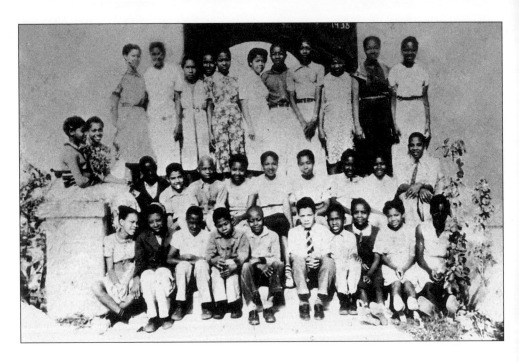

*Grades six through eight at Attucks High School—
Leroy Saunders, far right in the second row*

for my mother. She was my mother's best friend when they were children. She spent a lot of time with my grandmother. In fact, she stayed there because her mother and father worked on the farms, and she loved to come over, and my grandmother was a magnificent cook. She would come over early in the morning, and sometimes she would spend the night. My grandmother said she was the cutest, sweetest little girl. Well, the superintendent of instruction came because she knew how to read when she went to school, and he said to my grandmother, 'You shouldn't be teaching the little black girl.' They didn't do anything, but he said, 'You ought not to do it,' and 'Don't teach any more black children how to read.'"

Leroy Saunders, a retired garment presser, moved from Miami to Hollywood in 1928 when he was four years old: "School was very good. That was an uplift for us. The school wasn't large—there were four big rooms starting with first, second, up to eighth grade. They added ninth grade later on. I went through ninth, and took the high school home study course when I came out of the service. You saw a crowd every day coming up the sand road, and we went 22nd Avenue to school, so we met there. We came home for lunch. The teachers were very dedicated, and we learned a lot. It wasn't like today. You had to do well. You had to excel in everything. And the school was kind of religious. They had chapel every morning. They would meet if something happened, and I learned a lot of Christian songs you don't find in any schools today from our principal, Professor Ely. He played the piano, but he didn't do it often. A lot of the teachers played . . . a lot of the kids were interested

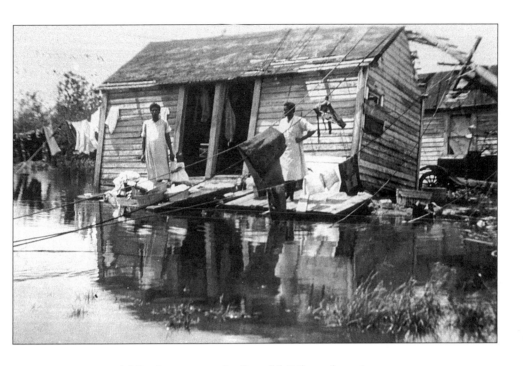

A black community hard-hit by a hurricane

in the piano. That was one thing—in Dania, we had four or five taking music from Mrs. Morrell. She was this teacher that went from place to place. My sister and I took music. And another couple took music, another boy. But we stopped early because she moved out of town, and I got a job on Saturday. Any time you got a job to work half a day you took it. So I couldn't take the music. But I took music when I came out of the service myself, a home study course, and I learned how to play. I played for the church for 20-something years, and with the choir, from what I learned."

He remembers his early impressions of growing up in the difficult times and instances where even a simple shopping trip outside the neighborhood could turn into a dangerous encounter: "When we came from Miami, we lived on Simms Street. There were a lot of rental buildings there then, and actually, they had restrooms on the back where a lot of homes didn't have them. But evidently they couldn't keep up the rent because, after a couple of years, we moved somewhere else. And my mother used to use the expression 'we got notice to move.' I didn't know what that meant, then, but it was a tough time. So wherever they could, when they had to move they'd solicit another place which was sometimes better than where we lived before. We moved further north, what they called 'up on the hill' toward Dania to a house, and we moved again to an abandoned house. It was, like, in a wooded area. And the house was nice. It had a dropped living room, and we cleaned around it, and then everything worked fine. I even made a garden. But after the first rain we found the mistake we had made. It just poured from everywhere. You can't trust these abandoned houses, you know. But the Red Cross told them that no one owned it, so they could live there.

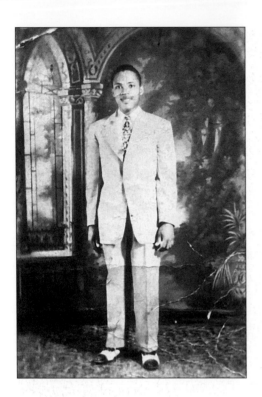

Leroy Saunders, age 18, before entering the service

Well, my mother bought two lots. She worked for . . . a real estate broker. I don't know how many days she worked a week—she was a cleaning lady—but he paid her $2 a day. She purchased the lots, I think, for $10, and she would leave $1 on the lots every time she would work, and she would take $1 home. Well, $2 went a long way back then. So she paid for those two lots, and eventually we started to build. It was a six-room house.

"In 1935, the hurricane came through, November 4th, and they were cooking, and she left the wood stove on. My mother loved the wood stoves. My grandmother had a kerosene stove. And we had to abandon the house because the storm got so furious, and my dad had got cut with a piece of glass, and they'd taken him to the doctor. So, she had to leave with the six children and go to shelter, somebody else's house, and left the stove on. The house caught fire. Another roof struck it, and it was demolished during the storm. And we lost everything in 1935 in that hurricane, everything. I saw houses blow away like birds, looking through a glass door from where we were staying [for safety] at the time. It actually traumatized me. After the storm, people went around looking, and I couldn't move out of the kitchen. I just had to shake . . . I'd never seen nothing like that in my life.

"After that, they'd had a lot of parameter tents. The city, the Red Cross, gave tents to everybody that lost their homes. We didn't get one because we could live with my grandmother. She didn't lose her home. So we moved there. They gave them a certain time for the parameter tents, and those that didn't have a place when that time came, they came round and collected the tents. And some of the tents were snatched up from the dwellings. Children came from school, people came from work, and everything was exposed. That's right. They didn't go beyond that deadline. But they were good. The city was good. They had a soup line. They served breakfast and supper. You could go down and get two meals. But times were bad, and during some bad times, the relief came out and brought food to the people—dried milk, Milk-O-Wheato cereal, butter, canned milk—and it helped a lot. Sometimes they brought clothing for before school opened for the children—cloth goods, jeans. My mother made all of my sisters' dresses. She had a sewing machine with the foot pedal. She sewed at night. But there were some good days there.

"My father farmed tomatoes. My mother had an acre of peppers almost every season and everybody else had two or three acres, and sometimes, it would do good unless we had a frost

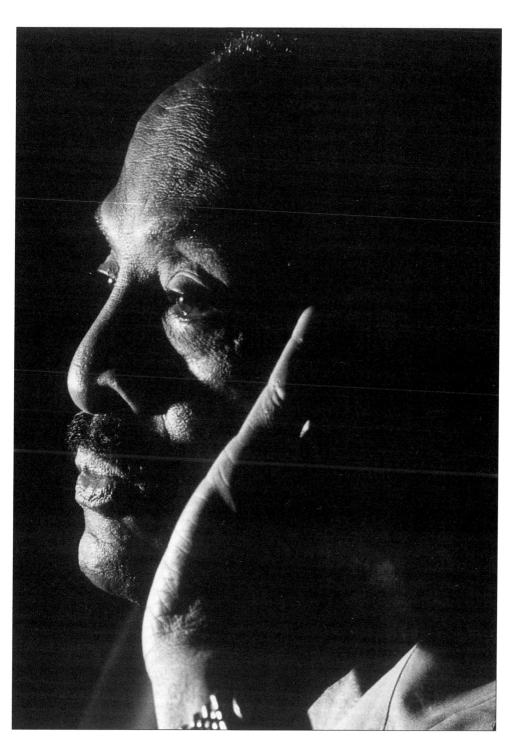
Leroy Saunders

or a freeze during the winter. But we had a packing house in Dania. And we would harvest the fruit, build the crates. You know, I was about 10 or 12 at some of those times, but I even knew how to build the crates, wrap the fruits, and put the tops on the crates. And my dad had a pickup truck, and he would take them to the packing house and ship them off. Then we would get a check in a few weeks. And he did excellent with that farming. I mean, it worked, you know.

"When I first moved from Miami, I didn't know any different (sic) [between races]. We were taught in the mornings to say, 'Good morning, Ms. –.' So one day my mother was taking me down to Dixie [Highway] to a store, and a white lady was in the yard, so I said 'Good morning,' too. My mother said, 'Don't do that.' She looked at me and said, 'White people don't speak to colored people.' Well, that's the first I'd heard that. I was about five. We didn't have any bad racial experiences because the people my mother worked with and my grandmother worked for, they could go there and they used to take us and they would serve us breakfast, or something. And the people my dad worked with, they used to come by the house and bring their daughters, and it was, like, you know, a good relationship. But later on, I found out that there was a difference, you know—mostly in the business places.

"My mother used to send us across the tracks into Dania to the [A&P to shop]. Coming back, a bunch of white boys would chase us with sticks. We had to run with our groceries. We did them nothing. But we had to go every Saturday to get our groceries until we could get [transportation into Hollywood] to Piggly Wiggly. But you couldn't call the policeman. We had no rights then. If a white man beat up a black man, there was nobody to arrest him, even if they killed one. So we learned how to live with it. [Our parents] would tell us don't let it bother us, and someday it would be better."

Shopping at a bakery "in town" in Hollywood could be bruising in another way: "I'd have to wait until the store was empty before the lady would wait on me. No matter what time I got in there, as long a white customer would come in, they wouldn't serve me. One day, they just kept ignoring me, so a white lady said, 'Oh, this gentleman'—and I was a boy—'this gentleman was ahead of me. I'm not next.' And the lady got all red in the face. She got mad at *me* and said, 'What you want!' That's when I realized the prejudice and [in my teens] as I started to working. Some people real nice, and others just seem to dislike you and do things to hurt you, regardless. You don't have to do anything to them. It's the white people that made the difference from up north."

CHAPTER 3

THE SIXTIES: LIVES CONVERGE

Nightlife. Gangsters. The first steps toward integration. Changes. Sam Dietz, 80, was around through those times. Born and raised in Wadsworth, Ohio, he started coming down to Hollywood in 1938; the family ran businesses during what was then the winter season and spent summers in Michigan.

Sam Dietz: "The Hollywood Beach Hotel was considered the finest hotel in the world. And the food service, it was considered the top hotel in everything. It always had shows on the weekend. Everybody got dressed—kids and little girls. Everybody got dressed on Saturday night. We depended on the employees. Figure one employee for every guest, and they had their own dormitories for them. They used to come in our place. When we built a new store we had a counter that sat 24 and seating for 72 people with the booths. When the hotel opened around Thanksgiving we'd open, and when they closed after Easter we'd close. We'd go there to Michigan and we'd work. When you're working 17 hours a day you didn't have time for anything. I knew there were [other] Jewish families. I got to meet a few of them. There were signs, but then it started tapering off; it started moving back in the '50s.

"We carried everything but prescription drugs. But our biggest thing was food. Everybody in Hollywood used to come and eat in our place. When my brother [Scotty] opened up back in '45 he was charging a nickel for coffee, and I think we were getting 25¢ for a hamburger, 15¢ for a hamburger. Back in the '40s gambling used to be in Hollywood. They had casinos . . . used to be run by the different syndicates.

55

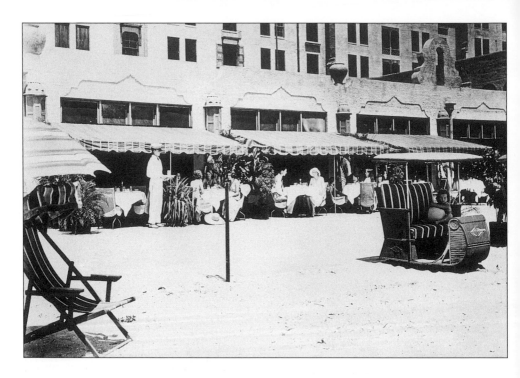

The Hollywood Beach Hotel, late 1930s

They ran 43 days in the peak of the season. Meyer Lansky used to come in everyday—nicest man in the world to talk to. He'd sit and have coffee or a danish. Used to be four men come in every Sunday. Nobody knew 'em but us. We never even told the girls who they were 'cause the girls would get all shook up. [The underworld] brought in a lot of dealers and their wives. They'd work 43 days, and they'd bring their families with them. Lot of show people. These people used to hang out at our store. They had big shows at these clubs. Big names. Nice element. No crime. You could walk down the street at night; nobody bothered you. This club in Hallandale, Danny Thomas was playing there. He'd stop at our store every night. He'd want a pack of chewing tobacco. The first time he came in my sister was there, and she looked up and said, 'Oh, you're . . . ' and he said 'Shush.' He didn't want people to know.

"These people who come down and stay at the Hollywood Beach Hotel, these were the wealthy, and they had their own chauffeurs. These were nice looking men, and they couldn't stay on the beach; they had to go to Liberia and get a room. The way our store was setup, we had a booth in the front of the air conditioner, which was our office. My sister sat there, and she did all the books. They used to call that the owners' booth. The rest of the booths were on the other side. These guys would come in the back door, and they were dressed in their uniforms, and we said, 'You want to eat, you sit over there in our booth.' There was a lot of glances, but we didn't care. I wasn't brought up that way. 'Course, some of the colored people would come in that worked the beach, and they'd sit in the kitchen and eat a sandwich, and we didn't say nothing. That's what they wanted. But the chauffeurs—

Sandy Eichner and her late husband Seymour in Miami Beach, 1955

here's a man working for people worth millions, and he can't eat a sandwich?

"We weren't getting that much of the Southern business. We were getting the tourist business. Now, we hired a girl from Georgia, a real Georgian. And one day this colored woman came in with these two little [white] kids—they were tourists—and she sat down. This girl from Georgia came back to the kitchen and said, 'You mean I got to go and take her order?' I said sure. I thought she was going to walk out the store. Maybe if we had more of the southern, what we call 'the old crackers,' it would be different."

Sandy Eichner is a Northerner, a native New Yorker, who moved to Florida in 1953, stopping first in Miami Beach: "I was conscious of the large black population [in Jamaica, New York]. In high school, we mingled during the day. I was about to say that I had friends, but I guess they were acquaintances because I didn't see them after school. When I moved to Miami Beach I was really taken aback when I saw separate drinking fountains, separate restrooms, and curfews. At that time, there was considerable prejudice. [There were] a couple of places where Jews were not welcome. And there were signs, "No Jews, No Dogs." Jewish people could not even think about moving to Fort Lauderdale at that time.

[In 1963] there were only two houses on our block in Hollywood Hills. There were cows on the street. There was no Emerald Hills at that time. A lot of building was going on—a lot of establishments. A lot of young people were going to Hollywood—young professional people."

A wade-in at Fort Lauderdale Beach in the 1960s

A lot of changes were occurring all over the country. After a 75-day Senate filibuster, one of the longest debates in history to block a piece of legislation, the Civil Rights Act of 1964 was passed. The law, banning racial discrimination in public accommodations, employment, and voting, was touted as one of the strongest in the nation's history. In a brief speech after the televised signing, President Lyndon Johnson said, "It's purpose is not to divide but to end divisions which have lasted too long." In the aftermath of the assassination of Dr. Martin Luther King Jr. and the rioting, marches, and racial unrest that followed, a group called People's Friends emerged from Eichner's living room one day: "We had a meeting of the League of Women Voters at my house—a small group of women, one of whom was black. We talked somewhat about [the racial problems], and we all acknowledged that we worked together in some instances in business—we are involved in activities such as this organization—however, generally at 5 o'clock we part company. So we came up with the idea. There were two black couples and four white couples. I invited one [white] couple in the group who happily accepted the opportunity. I invited another friend who said, 'Oh, we couldn't do that. We have a Fascist living on our block.' Need I say more? That evening it was just coffee, and later on we had potluck suppers. We grew to as many as 35 couples [meeting] in each others' homes, [and] we had picnics with the children.

"I learned firsthand my new friends' early experiences with prejudice, the exclusions. It's quite one thing when you read about [it], and you think

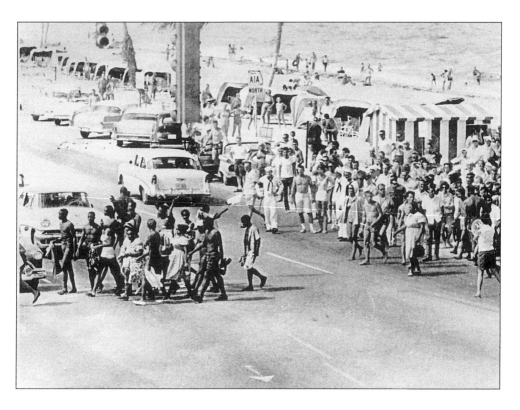

A civil rights demonstration at Fort Lauderdale Beach

you're emphasizing, but it's quite another when you come in personal contact, especially on each others' turf.

"This will give you a flavor of how I felt. We were invited to a [fraternity] ball called a 'Black and White Ball,' not because there were blacks and whites but because that was the attire we were wearing this night. We had a great time. I didn't think a thing of differences until I went into the ladies' restroom and suddenly my pale face reflected back at me in the mirror. It's a strange thing to express, but it just smacked at me at that point that I was perhaps one of three white couples in the entire room. Up until that time it was just a blending of personalities and had not even been a focal point of mine. I had hoped to resuscitate [the group] at one time, but it never got off the ground. Sometimes these things are just time limited."

Sam Dietz: "We could see there was new places opening up. We was getting all these fast food places coming in, and the Diplomat Hotel opened up, which drew a lot of people away from the Hollywood Beach Hotel. So, you could see things starting to change. All these condos were going up, which ruined the hotel business. It started getting tough finding help. We started using high school kids; then we started using colored people. That's how we brought the first one. A lot of girls didn't want to do that kind of work anymore, waitress, and a lot of these kids were going to school. They wanted part-time jobs. So we used to use a lot of colored people at night, after school, as waitresses.

"The first time we hired Alma Bradshaw there was flack from some people—a few. We had one fellow,

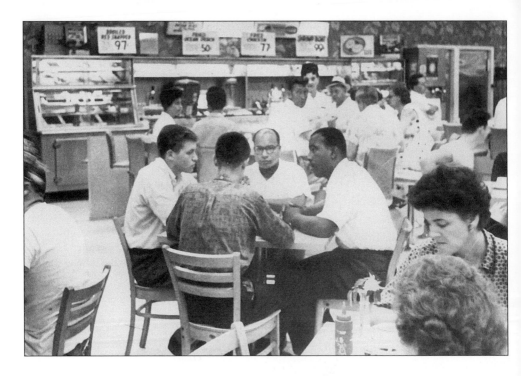

A sit-in in Florida

he used to come in every morning for cereal and a banana. He sat at the counter, and she walked up to him. He figured he didn't want a colored person handling his food and to peel a banana and slice it for him. Every time he came in he made sure what section she was in. Things were starting to change a little bit. Then we hired a colored fellow to work in the kitchen. I don't know if he was the first, but he was a nice fellow.

"The mayor of Hollywood [then] came down to check us out. First time they ever saw that in Hollywood, in the '50s. [Alma] was doing housework for a friend of mine, a dentist. She wanted to work for us, and then she was with us two years, and that's when Bob Anderson [and] Cathy would come in and have lunch with us, and he approached us and asked if she'd be interested in going with the bank. He had to hire a teller. She didn't want to go at first. She was afraid, but we talked her into it. I think she was with Bob four years up there, or five years, I think. She quit and went to work [at the bank] across the street.

*C*athleen Anderson: "I worked at the bank since 1956. In the 1960s [my husband] Bob and I used to eat a lot at this Scotty's Sundry down on A1A. Alma Bradshaw was a waitress. One day we were talking, and Bob was the president of the bank. Alma said to Bob, 'I've always wanted to work in a bank.' Bob said, 'Really?' And she said, 'Yes. I thought about being a teller.' There was no black tellers in the banking business in Broward County, and Bob was a native of Hollywood, so Bob said, 'Alma,' he said, 'Why don't you come in.' He said, 'I will hire you as a teller, and then if you don't like being a teller, we'll get you a job somewhere else at some other place in the bank.'

Cathleen Anderson

Alma was afraid. That morning, Bob said to Alma, 'Come in early, before the bank opens, and we'll, you know, fill out the papers for your payroll and all.' Back then, we used to have the head teller who was also the vault custodian that counted the money when it came in from the Federal Reserve and gave the money to the tellers to use. Well, Bob said he took Alma back, and he said, 'I want Alma to be a teller.' Now this is the president and C.E.O. of the bank. The man who was the vault custodian and called the head teller said to Bob, 'I'm not going to teach any . . . ' and he used a very derogatory term, ' . . . to be a teller.' And Bob said, 'Well, if you won't . . . I'll teach Alma how to be a teller.' And so Bob stayed in the cage with Alma for one whole week and part of the next week and taught Alma how to be a teller. And we had only a few incidences. There were a few big customers of the bank that didn't like it."

Henry Graham, in his early 50s, was one of the many young black schoolchildren growing up in Liberia encountering the animosities of segregation and coming of age in the first painful throes of desegregation. He remembers going to the supermarket and stopping at a fountain to see what "white water" tasted like: "I was approached by the manager, and of course, he knew my grandfather, and he informed me not to do that again; I could get myself in trouble because a few whites came to him and said, 'That nigger is drinking out of the white fountain.' And I had some smart words to say but he said, 'I just want you to leave the store before anything happens.' That was one of my early encounters.

"[Later] at Edward Waters College in Jacksonville, we were downtown shopping and the local radio station started making an announcement that all blacks should get off the streets and get back into their neighborhoods immediately. Being fresh out of high school and in a college environment in Jacksonville, I continued to shop. All of a sudden I saw these hooded groups coming with the hoods over their heads and, of course, I knew about the Klan. That was a real eye opener. And, yes, I moved real fast. The black community was well equipped. They had vans and other modes of vehicles to pick us up wherever they saw blacks downtown, to get them out of downtown in a hurry. And it was quite educational and an experience to really see racism that was such that you were not allowed to shop downtown after sundown. It was getting dark, and it was like, it was time for the blacks to leave."

Elisha Moss Jr., a veteran schoolteacher, was born and raised in the then-unincorporated black community of Carver Ranches, just south of the city that residents called West Hollywood around the same time: "One of my earliest experiences I never really shared with anyone until years later. At that time it made an impression on me, but by the same token, I sort of pushed it aside. I was probably still elementary school age, maybe fifth or sixth grade. I can recall having to walk through basically a white neighborhood to go to the supermarket. I was walking by myself—it was about a mile from where we lived west of West Hollywood. I can recall I was walking to the store, and there was other kids, other children—they were younger than I was. They were out playing in the yard, and when they saw me walking by—I was going to the store not saying anything—they noticed me and stopped, and they started calling me names using the 'n—' word, and so forth. I didn't feel threatened as if they were going to physically

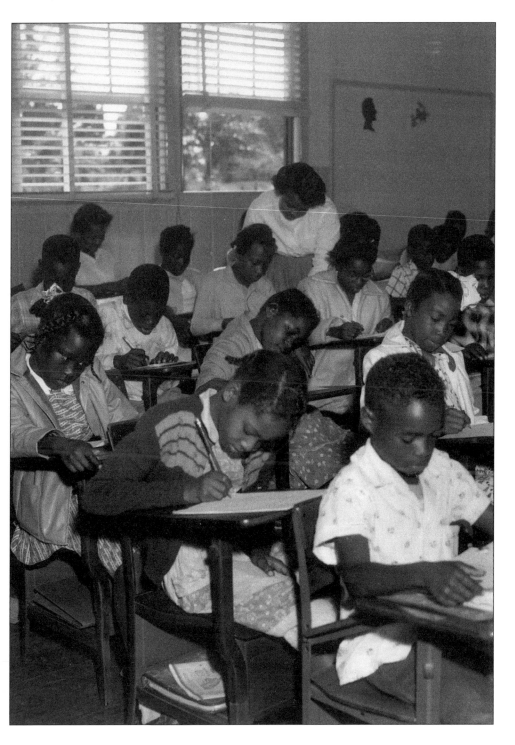

A typical class at Attucks School

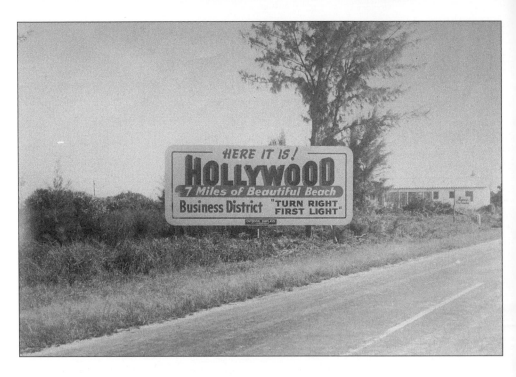

The sign points way as building booms from late 1950s on.

harm me; they were just playing. But by the mere fact they were saying that, I felt the hurt. My mother had talked to us at different times about conducting ourselves. She did not deal on racial issues because we really weren't confronted with it that much, but we were raised to respect and love everyone regardless of race, color, or what have you. That was one of the first and practically the only one until I started college. I just felt that I dealt with it.

"As far as having to cross and going into others' neighborhoods, we didn't do much traveling. My older sister would take us to Virginia Beach or Port Everglades; we had a little ferry to go across over there. Those were the two beaches, and they were segregated during that time. As children, it was a pretty much self-contained neighborhood in that area."

Joyce Dent has moved back to the southern edge of Hollywood, called Washington Park, where she grew up from the age of three. Just across Pembroke Road from her home is Carver Ranches. She graduated Attucks High School in 1966. She remembers her early impressions of Hollywood: "I remember it being vast. When you're a child everything looks big. The area we lived in it was just wilderness. I saw a little bear. I saw deer. I saw a fox. I saw big snakes. I had no friends because the next neighbor was three blocks away, and that was [the] only house. I call it the pioneer days. I remember Indians being on U.S. Highway 441 when it was a two-lane highway, and I thought, Wow, this is good. A child would think that. I didn't know it was out in the boonies.

"People began to migrate in. There was no places to play. Our beach access was limited. Virginia Key was the

highlight of my summer. Nobody told me that all the other beaches were restricted. I just thought that's where we go. They had entertainment for the kids, and my mom was having a good time, and I was happy to see her happy for a change. My brother and sister, they were tiny but they had fun. Until I got to high school, my world at that time was that street, the neighbors' kids and whatever mischief we could get into playing with each other. As we grew a little older to go to middle school, I always had this fear of going to that next level. It was just an anxiety building up in me. And then I heard about this other school, McArthur, and I thought, Well, I'm closer to that school. Why can't I go to that school? Someone said only the white kids go to that school. I said, Well, okay. It didn't make any difference to me. I didn't know there was such a great difference until I got into the ninth grade [at Attucks]. I heard people saying well, we get the second-hand books, and that always bothered me. I think the reason I remembered it so is because it impressed me. I can't get a brand new book? Why can't I? I'd always get the torn up books with somebody else's name in it—a kid I had never met. They said the white kids get the books, and then we get them. I think that began my rebellious attitude, very quietly so. It was just a mental attitude I had. I'm good enough to have these things. Why can't I have it? My mother said, 'This is where you go, and that's it,' so I just had to accept it.

"I remember I was given the opportunity to take some advanced classes in high school. I used to say to myself, Why is this teacher so hard? He was a history teacher. I can't remember his name for the life of me. He often said, 'When you get out there, you're going to have to work twice as hard to get the same job as the white kids,' and I said, I don't understand why. If I'm good enough, why can't I? I didn't understand that kind of prejudice. I wasn't taught that at home. Only if I asked a question would they say, 'Well, that's for the white people and this is for you.' There was no explanation behind it. I always thought I was good enough; I just never knew why other people didn't recognize that. I couldn't go to McArthur. I couldn't expect to go to college. I was often told 'Finish high school and get a good job,' and in our household that meant work for some prominent family, clean the house, be a cook. The choices were teacher, nurse, or housework.

"One day on the track field some men came down from New York talking about what had happened in New York—the rioting, the marches. They said, 'You people really don't know what's going on.' I think it ignited something in a few people, especially the senior people at that time. They became rebellious one day. We wanted to go to [the black beach in Hollywood], and the principal said okay. Well, the school board didn't want all those black students out of school at the beach at one time. Why not? The white kids get to go everywhere. That was something like a mantra all over campus. It was the first time I'd seen mass togetherness at anything. They put up roadblocks, and the police were standing there trying to get us to go back to school. There might have been seven students in that whole school. We left; we went home. I figured, well, they can't beat us all. I woke up, and I've been fighting ever since.

"I think it was that summer, the kids on my block started a fight, and they started rocking cars. They said, 'We're going to burn the town down.' That didn't appeal to me, so I stayed in. If you were white you got hurt."

Bob Gossett, 50, is a white Hollywood attorney who also remembers those times: "There was a section in southwest Hollywood, Carver Ranches, that we were told not to go to, and of course, I grew up during the race riots, and you got scared of going to those areas because you didn't know what was going to happen. When I was in high school we played in a summer basketball league, and most of the games we played were at Attucks High School, and I can remember being a little frightened, I guess, to get out of that neighborhood quickly.

"There really wasn't much distinction in my mother's family's attitude from the north and my father's family's attitude from the south. They seemed to have the same attitude—a separation. Black people were different.

"The best thing that ever happened to me was being taken under the wing of a man that worked for my father—Buster, the chief laborer. I was the boss's son on the dumb end of the shovel, and [he was] the guy that was to kind of take care of me and make sure I didn't goof off and teach me. One Friday night I had to take something out to his house [in Carver Ranches] during the mid-60s during the race riots, and Buster was sitting on his front porch with a shotgun laying across his lap because nobody was going to damage his house he'd worked so hard to make very, very nice. I was about 16. To this day I don't understand why the riots, the burning, the lootings occur in the black neighborhoods."

Kevin Swan, a classmate, lived a very different life on the ocean side of town. His family moved from Harrisburg, Pennsylvania, to Hollywood Beach in 1956 because of his asthma: "I came at 8 years old. I was referred to as 'a beach kid,' cleaning apartments. In the summertime, you could shoot a cannon off, from Hollywood Boulevard bridge down to the circle; you may never see a car. It was very quiet. Fishing, skin-diving, scuba diving, no licenses to get tanks filled up. Lot of sailing. We had a small outboard that we kept at Hollywood Yacht Basin. I was like Huckleberry Finn, in a way. I worked every afternoon delivering papers. I worked at Joe's Market on Hollywood Beach. There were always jobs. Living in Florida required both parents to work. We had a good life, but we were always pinching pennies. My mother and father were very frugal, very Depression-era mentality: waste not, want not.

"Even in the '50s, the Canadian market was predominant. But it was an international mentality. It wasn't Miami Beach where people came for glitz, glamour, and floor shows. The Diplomat was being built; I remember watching it when we were on the school bus. In our hotel, we called it international because we'd go though periods where everything was represented through the entire season. We had Italian time, Polish time, Czechoslovakia time, West Virginia time. They came in groups. It was like getting new neighbors, but they only stayed for one or two weeks, so they didn't wear out their welcome.

"My whole world was white until high school. Starting to work and traveling and going to college, the world started to open up. You saw [racial problems] on TV, but it was always somewhere else. It really didn't enter into your particular life. Being white and living in Hollywood, I guess there was an air of superiority from a standpoint. This is a question I've never thought of before. There wasn't any section that we thought we couldn't go to. There wasn't a thought that we couldn't go there because that section is black.

Bob Gossett

A giant mural depicting Hollywood Beach and the Boardwalk

Kevin Swan (second row, third from right) and his swimming team

I guess there was a sense of superiority, but we never thought about. On Friday night, I was the one deemed to be the one to go buy the beer when we were in high school. I'd go to Far Away Joe's in Hallandale, and Dania, on the corner of the cemetery, which was called 'colored town,' now called Liberia. But we never thought about it, going up to a black person and asking them to buy us a six-pack of beer.

"In hindsight, I guess there was an air of distinction that was subconscious. There wasn't like, 'Well, you just go get that for me.' It was always a question. I was taught to be respectful, no matter who the person was. But in hindsight, I guess there was a difference.

"Me being a swimmer, I wasn't a football or baseball player, so I didn't have a lot of interaction [with] different races in sports, which a lot of other kids would have had. It was a predominantly white, country club sport. I think there was more segregation in South Broward [High] based on religion. Hollywood had a lot of Jewish families. Fort Lauderdale was very WASPY. Trying to find a synagogue, even today, you'd be hard pressed to find one. So, a lot of [Jews] moved to Hollywood. We made jokes at Hollywood Central [Elementary] when it was Rosh Hashanah or Yom Kippur . . . 35-37 kids in the classroom; on those holidays, there would be only 3 or 4 kids left. We were the only WASP kids there. The rest were all Jewish kids who lived in the area."

Susan Abrams Heyder, who is Jewish, was also a classmate. During those growing up years, her late father, attorney Maynard Abrams, was a long-time city commissioner; from 1967 to 1969 he was mayor: "[My upbringing was] pretty close to perfect. I had two brothers. It was a wonderful time. We went to Hollywood Central. We would play at the park every afternoon after school. We went to McNicol Junior High, and immediately across the street from us was Lanier Junior High, the black junior high.

"My parents were wonderful people. My father's gone. My mother, Gertrude, was a housewife. They got married in Jacksonville. My mother was from Live Oak. My dad went to the University of Miami, and his family was in the Miami Beach area. When they first got married, they lived in Plant City between Lakeland and Tampa. He was flying, a private pilot. They bought an airport in Plant City. One of his fraternity brothers and his wife moved with my parents to South Florida for the weather, and they settled here. His fraternity brother became an optometrist in downtown

Susan Abrams Heyder with her parents, c. 1970

Hollywood; his son grew up with me. They bought a hotel in downtown Hollywood, and they just stayed in Hollywood. [Eventually] he went back to law school and became a very successful lawyer, later in life.

"My mother would tell you to this day, they were one of the only two or three Jewish families in [Live Oak]. She said she found it very interesting because there would be nighttime meetings of the Klan, and she could tell it was her principal underneath the robe. She said it was very interesting. They were obviously treated differently in school. The other two families were her cousins, by the way—my uncles and aunts. They were ostracized because they were Jewish. They weren't included in parties and things outside of campus. They did things within the realm of the school, but it would be obvious that their brothers and sisters weren't invited to a party going on in town at somebody's house. She'd see [the Klan] downtown. You could recognize people, but you knew not to say anything. My grandfather had a store there. It was very common for Jewish merchants, actually. It seemed like in every little town in Florida, my mother's family . . . had one. There was one in Green Cove Springs; Haines City; they had family spread out . . . Tallahassee. That's how it was in old Florida.

"My mother's mother was born in Philadelphia, and my grandfather was born in Houston and somehow ended up in Jacksonville. [My father] was born in Chicago. He moved to West Palm when he was three . . . graduated [high school], then moved down to Miami Beach. [He] had asthma. They moved to South Florida to cure it. It was going to solve the problem.

"I really hate to sound stupid, but I'm not so sure that I was ever aware of being different. As I look at you, and I think we were much the same age, and the difference between us is visible, but it isn't in our hearts. The difference to me as I would walk the street would not be visible to someone else, and I was always told—even now, people say that I don't look Jewish. I would think, 'What does that mean? I *am* Jewish.' I didn't ever see that as a negative, but it's a visible difference that we share. But you're still ostracized in life in different ways from different people. You more than I, perhaps immediately. Because once they find out that I'm Jewish, there are those who are going to be negative and deal with it in their own way.

"We always had—when I was a very young girl—we had a woman, Artie Gregory, that worked for us five days a week. She's still my second mother. We see her all the time. That was really it. It was a very separate existence. She came; she worked; she went home. But when I was, I guess I'd started [high school] at South Broward, she had a nephew, Benny Johnson, who went to Attucks. He was in a play, and I went to that play. I was the only white face at Attucks that night, but I loved it. I thrived on it. It was so exciting. It was *Macbeth*. I thought it was so fascinating. I never really thought anything of it other than the fact that I know there was a time in my life I realized, 'How stupid.' Attucks was across the street from South Broward, virtually. That's just the way things were, as you all know. I didn't think it was a good idea.

"I don't recall seeing African Americans downtown or at the beach. It all sounds so bizarre when I look back. You'd never see black people anywhere except working at people's homes. In my case, I did. I'd go to Artie's house. She'd take us home. We knew her nieces and nephews. One is a 6-foot-10-inch monster! I'm sure he's not that big, but he got really big. I really have to say that my parents were very fair-minded. There was never a verbal attitude to me. [But] if I were to have dated anyone of another color, as my kids, things would have been halted much sooner. My daughter has been dating a black guy for five years. My dad's been gone all this time, but my mom said, 'Maybe, you'd better talk to her about that.' And I said, 'Well, we've welcomed everyone in our home all these years.' Even when we were hesitant in the beginning, we had a discussion with both of them when we said, 'You should think about your children if you're going to take it that far.' All three of our daughters said to us, 'Mom and Dad, you've always welcomed everyone in our home. Don't start changing things now.' And we said we wouldn't, and we haven't. [When] I started teaching in 1970, I taught with black men and women, and never did I think of them differently. So, whatever I grew up with blended with my life later on. But I do have to look back to think that it was very different.

"At our 20th high school reunion, I was involved in the planning as usual. We went to a place . . . and my father was alive. I said, 'Oh, my gosh, this place is gorgeous; it's right on the beach. I don't get it. Daddy, why didn't we ever go there?' And he just looked at me like I was crazy, and he said, 'They wouldn't let us go there.' At that moment, I decided we had already committed to this place, we were going to this place,

Seniors from the 1966 South Broward yearbook

but [we] won't go back there. It's just something, you just don't feel the desire, which is kind of crazy. But that's it. To say that I ever felt [racism], maybe I was sheltered or kept from it. I don't feel that I was. But I think that's just the way it was. There were very separate venues where African Americans would be—where whites would be. It was just very separate. I don't think it was negative. Now that I look back on it, I see it as a negative. I often wondered why there would be a school right across the street from another school. We always played sports with white high schools. It wasn't until I got to [college in] Gainesville that I recall going to school with blacks. And I remember how few blacks there were. Not that it was odd, but how uncomfortable people must have felt. Like I said, my difference isn't a visible difference initially to people until you get to the hardcore nuts that are out there that find out and treat you differently.

"I looked at my yearbook from 1966, and there were some black faces in our class. I do not recall anybody. I never communicated with them. I'm involved with the reunions, and I do a newsletter, but I never had any address to send out anything to them. One was a girl. She's probably married and a different name. Now, I'm beginning to feel so sheltered having been in Hollywood. But it wasn't until later, when I was on my own, that there were things going on, very obvious. It became the late sixties, the hippie movement. People were speaking out. That's when I remember thinking that there was a lot more going on in the world than what was in Hollywood.

"The way that the sorority system is set up at Florida, you would go around and visit each sorority house.

I don't remember how many—say 14 to 16, maybe less. You had to go to each house. Then, you're invited back to the house that found you interesting. I can't remember whether you were required to put your religion. I'm certain I did because if I'm asked that, I have no hesitation in putting it down. We often found that nine out of ten Jewish girls were asked back. There were two Jewish houses, and one that would take Jewish girls, so there were three houses that invited you back. And that's the way it was. Even now, I just had a mini reunion with some of my sorority sisters at the end of June, and we discussed that. We've all gone our own way. Many of us are not married to Jewish fellows, but we've raised our children Jewish. We all comment that it's very interesting that in those days we first began to feel that we were different, so to speak. It wasn't the immediacy of somebody walking down the street saying, 'You don't belong here,' as much as it was, once they found out, then we didn't belong. I never felt that until then.

"I see that in so many towns where my family is, the Jewish population tends to stick together. There's strength in numbers, a comfort level. People are more comfortable with someone that shares your own values and background. Just making someone Jewish or African American doesn't mean they're friends for life, or meant to be. But it certainly is a starting point, a little more of a foundation.

"When I came back home and I wanted to teach, it was very difficult to get a job. My father called somebody, and they called somebody. I got a call from a principal, and he happened to be a black gentleman. Actually, he was not a principal, he was with the school board, and there was a conversation on the phone. He said, 'Well, you know, if I put you in a school, it would be primarily black. Can you deal with that?' I said, 'I'd be thrilled to deal with that. I want a job.' It was almost a threat. I thought it was very interesting. I ended up at a primarily black school. I absolutely loved it. They had started really shuffling the teachers so that there would be more of an equity and balance, but I was only there six weeks because there was such low enrollment. Looking back, probably some may have been antagonistic. Maybe that's not the right word—but looking toward me as somebody in the wrong place. I felt it could have been a really good working situation had I stayed longer. We'd have little faculty parties, but not a whole lot outside of campus. It was 30 years ago, so there were some differences. But I look at it so differently now than I did then, when you were living through it. I really didn't feel it because I didn't want to. I never thought there was anything different about myself from anyone else."

Most whites in the area during that time remember more the rivalries between South Broward High and the newer school, McArthur High, which opened around 1960, than any racial awareness. Eileen McDonald moved to the Driftwood Acres community from Queens, New York. Albert McDonald grew up around Fort Lauderdale. They attended McArthur, which was in the underdeveloped western part of Hollywood around U.S. 441.

Eileen McDonald: "When we'd get together [with] South Broward for football games, you could tell there was a hostility, but it was more of a fun kind of thing. They used to say derogatory things because of the name—being a dairy because it was Mr. McArthur who gave us the land, and his dairy was across the street. They would sling different things at us . . .

the ones that owned the dairy farms and rode horses. More cowboyish, whereas South Broward was more in town. They lived in a completely different area."

Albert McDonald: "Everybody who went to McArthur was considered the west Hollywood group. The motorcycle gangs. You have to remember that you had bars . . . there was places you had to stay away from just like you do today, but back then, it was easier to know which places because there wasn't that many places to go. Everything was in a confined area so far as businesses and everything. Plus you had the Indians. At that time, they still lived in chickee huts. They didn't live in CBS houses out where they are now."

Eileen McDonald: "I loved them. They were the nicest people. The chief now, I had one of the biggest crushes on him. Him and I went to one of the dances on the reservation. They never said anything bad about anybody, and everybody loved them. They mixed with everybody. They were right there in the middle of everything.

Albert McDonald: "I remember the girls coming to school in their multi-colored skirts and everything. They played all our sports. I knew they were Indians, but I couldn't tell you who was Jewish or who was from New York. You were friends or you weren't friends."

Eileen McDonald: "When we first moved into the area it was very strange to me. It had a country store, an old wooden store . . . and places where you could tie your horse up. Coming from New York, that was really just kind of the neatest thing. And a dairy farm was over there, and a lot of cows.

Seminoles in Hollywood

Three or four blocks behind us was all cow pasture. And then the Indian reservation was back there. The Seminole Indians were just a matter of blocks from where we lived.

"When I was up in New York I went to school with black children. Coming down here and not seeing any blacks in the schools, I guess I just never thought anything about it. You just got used to it. It was just something we grew up with."

*A*lbert McDonald: "My parents rented a lot. We never owned our own home until I was 12 years old, when we moved down by Griffin Road and 441. I just remember going [to] downtown Fort Lauderdale with my dad walking downtown, and I remember the old Woolworth's and the Royal Castle and the theaters; he used to take me down to see movies. I have some real early memories of hurricanes in the early '50s. I can remember the project we lived in and this gigantic tree that had been uprooted and blown over. I think at the time, I was probably five or six years old.

"They were simple people . . . came down from the farms of Arkansas. [My father] worked at Gate City Lumber right by the railroad tracks. Later on, he became a night watchman. They came down here on vacation in 1942, and he saw all the farm land, and that's when they decided to move down here. I did have three sisters and one brother, and everybody else was born and raised on the farm, and I was born and raised here in the city."

*E*ileen McDonald: "[My father] worked for a bakery up in New York. He got transferred here, and from there, he worked for Frito Lay for 20 years. He delivered to a lot of the black areas. The one story I'll never forget him telling is in this one area in downtown Fort Lauderdale the little boys would come up to the truck, and he would throw them a bag of chips or whatever. The kids would always run around town when he pulled up to the different little mom-and-pop stores. Growing up these kids remembered him, and when the times were starting to change and the younger ones that were there then said, 'Hey, let's get that Mr. Lay's man,' the older kids that he threw the bags of chips to would say, 'Oh no, don't mess with Mr. Potato Chip man. Don't mess with him.' He was accosted a couple of times, but only a couple of times. Then the word got out to leave Mr. Potato Chip alone. That was the very first incident that I can remember of anybody that I knew having to go through something with the racial situation. That was probably, I'd say, early '60s.

"[Then there] was a race riot that went on, probably in 1961, maybe, '62, somewhere around in there. There was a drive-in restaurant with the carhops on roller skates and all that, at Pembroke Road and 441. That was the dividing line between blacks and whites. The blacks were on the east side and the whites were on the west. My brother was there; my brother is four years older than I am. [That's] probably the first time I ever realized there was a problem. How that ever started I really don't know. It was teenage boys. [My brother] wasn't involved in it that I know of because he didn't do that sort of thing, but there was guns; there was knives—both blacks and whites. That was a big thing that happened. There were quite a few on both sides. They met right in the middle of Pembroke Road."

*A*lbert McDonald: "I didn't know there were problems until I started seeing things on TV."

James and Nancy Dee in high school

James Dee, class of 1965, is a South Broward High graduate. He comes from a Dania Beach horse farm family that moved to Hollywood from Iowa and has had a longtime veterinary practice in Hollywood. He and wife Nancy Dee are typical of the residents interviewed who also recall those friendly rivalries between the "eastsiders" of their school and the "rednecks" of McArthur, but an absence of true racial diversity in their lives: "I was raised in Dania, and we had a horse farm out west. My father, being a veterinarian, had a lot of broken down race horses we took care of, and we kept the property up. When I was young [in the 1950s] we were out in what would be now 46th Avenue and Stirling Road, and that was in the boondocks. We were so far west it was tough to get into town. I don't remember hearing much in the way of radios. We didn't have air conditioning. We worked the farm—it was a rural area at that point. For vacations, we would all go up to a friend's cabin in the middle of the state around Lake George, which was the Ocala National Park. That was *the* main thing we looked forward to every summer. Later on, in middle school, obviously it was sports and big fairs every year to raise money for the schools. One of my fondest memories, I guess, was the old tomato festival that they had in downtown Dania during the harvest season. They'd have stadium seats and bleachers, and the kids and elders would get out there with those overly ripe tomatoes and make everyone red. It was an enjoyable afternoon.

"When I was at Stirling Elementary we had a lot of Seminoles. There were not very many. All the Billies and the Jumpers were nice kids, great in sports. Got along well with them. I remember going out to the reservation once on 441, biking out there. We went out and saw the parents, played with some of the kids, the dogs. They really did not have much to do, which is what a young kid is gonna look to get into. They had their own chores to do in the afternoon, working with the parents, with the garden, taking care of animals, working on the farm. That was a rarity that we ever intermingled out of the school environment.

"I don't remember ever seeing a black in South Broward High when I was there, or at Olsen [middle school]. I don't remember any encounters with blacks at all. We did not drive across the tracks in Dania to drive through quote 'colored town,' the black area—not because you were afraid, but because you had no business there. You didn't know anybody there, and all you'd do is get in trouble. I don't remember seeing blacks where we shopped, per se. There weren't any grocery stores clear out to 46th Avenue where we lived.

"The worst memory I have is, we had a woman who worked for my mother; she was our maid, Mary—wonderful woman, a black woman. That is probably the only exposure I had to blacks until I was into and almost through college. And probably the worst memory I have is I called her a nigger once, and I was brought down by my parents. It makes me shudder today. Sheer embarrassment. I was probably a smart aleck ninth grader. Maybe I was 14.

"I was at Auburn [University] about the time you had the marches. It was a little bit of a scary time. Everything was going on in Alabama. There was [also] something called Vietnam going on, and I really didn't want any part in it. I was working for grades. Once I got in vet school, then I was exposed to people—this was '68—people from Louisiana, Mississippi, Tennessee, Kentucky, the true South. Again, all white. But you did start seeing changes in attitudes that I was never brought up with down here.

They had a completely different attitude towards blacks.

"It was obviously extremely biased, extremely racial. These boys were from the South, and they knew the members of the Klan, first names. I remember driving through rural Alabama and seeing the crosses burning in the fields. It makes you put your foot to the pedal. It would be scary. They would talk about fighting, beating up blacks. This was not an uncommon occurrence. These were young men raised in the true Southern tradition. It was a little astounding because we really did not get that exposure down here. "

Nancy Dee: "As Floridians, we were not readily accepted because we weren't from the South. Florida is not the true South. We were treated as 'Northerners.' We had what turned out to be some very good friends born and raised in Kentucky, and when we first came in contact with them, they wanted nothing to do with us when they found out we were from Florida."

James Dee: "We were too far south. The South stops around Gainesville, Jacksonville, Tallahassee. After that, it starts working its way north again and you get down to South Florida, and you are Northerners [in the eyes of true Southerners]."

Nancy Dee: "I graduated Auburn in '70 with a degree in education, and I taught in Georgia, That was the first year the schools were integrated, and it was a real eye-opening experience for me, not having any background as far as that's concerned. When I went into that school we had audio visual rooms that we were unable to use because we didn't have the funds to run it anymore because [the donors] did not believe in integrating the schools. I taught special education and had a classroom of mixed children. One day I was reprimanding a little boy, Willie, and Willie really was angry at me, and his reply was "You white," whatever term he used past that. And then, in another instance, it was calling me a honky and so forth. It was difficult for him as well because he obviously was in a new situation with a white teacher standing before him."

In 1964, local newspapers reported that 21 black students enrolled in two previously all-white Broward County schools—Everglades Junior High and Rock Island Elementary—without incident, but ten white families asked to shift their children. Others attempted to enroll at Deerfield Beach Junior High but were turned down because they did not live within the district. By 1966, 3,000 black pupils were in all-white schools, and 100 teachers were desegregated—black teachers in white schools and white teachers in black schools—and Cato Roach Jr. became the first black school administrator.

Annie Thomas had moved to Liberia in 1942 from Perry, Florida, to setup a beauty shop: "When the children started going to school with whites, the schools began to be integrated. I was kind of afraid of it, but finally, the children made it happen. I noticed one year at Attucks—one of my sons graduated in the '60s . . . when he came home, I had to fix a—like when they have the graduation classes, and they go out that night, you know? The next morning, I would fix breakfast for all the children that was in his class, and there were some whites. The white children came here for breakfast that morning, and my husband, he called me in the bathroom.

'Annie, I don't want no crackers in here sitting at no table eating. You don't know what will happen. They be coming around here shooting around here at night.' I said, 'That won't happen. We just got to give in to this.' You know, I would talk to him. But he was very reluctant of white people coming around.

"And one of my sons had a classmate that married this white guy. My husband told him that he didn't want them coming to the house, you know. But later years, everybody began to feel [differently]."

*B*ob Gossett entered South Broward High in 1964. He remembers no black students at that time, but by the time he graduated in 1967, that had changed: "There were three [black] students that came in the fall of 1965. I played basketball, not because I had any talent but because I was tall and thin. Two of the students were

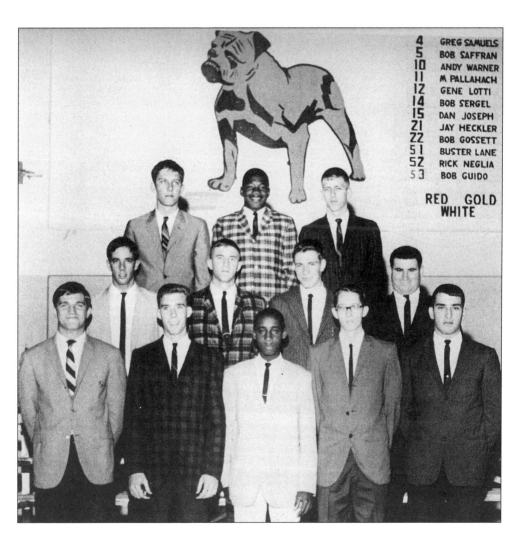

Greg Samuel (front row, center) and the South Broward High basketball team

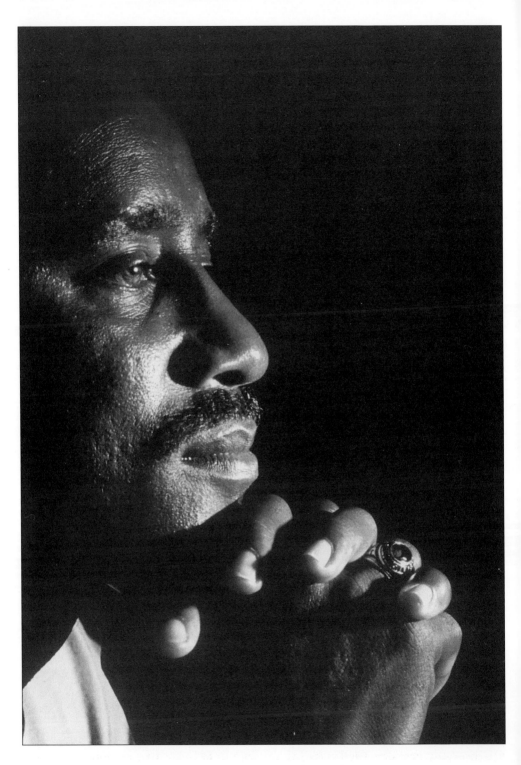

Greg Samuel

basketball players—Greg Samuel and Foots Warner. Foots was one of the funniest human beings I've ever run into. Greg was the antithesis, probably one of the most serious people I've ever run into. He hardly ever smiled, or so I remember.

"I can remember feeling some resentment towards Foots. He made everybody laugh, and he was funny, but there was also a resentment that he had taken my place. And people always have excuses, so some of us—and me included—would blame the coach. 'Ah, the coach is just bending over backwards for those black kids. He's not giving us the equal shot. We're just as good as they are, but because they're black they're getting to play and we're not.' I don't remember any racial problems. They fit in well. There was no name calling or jeering. As far as I remember, they had really smoothed the way for the transition to occur. We had a good principal."

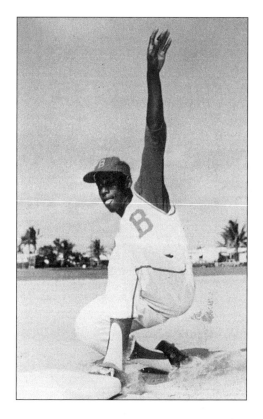

A young Greg Samuels

Greg Samuel, a lifelong Hallandale resident, didn't live in the district, he says. But he was allowed to enroll by requesting to take German, which wasn't offered at Attucks. He's a teacher and coach at Flanagan High; he also gives lessons in golf and tennis. Most of those students are white: "I was a good basketball player coming out of ninth grade, and the basketball coach at South Broward—he was white—he came to recruit me to be the first African American to play. He sat me down to try to get me ready for things that probably could happen with the racial climate. He was from New York, and this was his first year here, and he wanted to have a good basketball team. When he took me to school the first day, I left. I went to Attucks and hung out with my friends because it was so bad. Name calling. I felt like an outcast.

"It was real tough because, in class, I wouldn't say anything, and during lunch I'd go sit by myself because I didn't have any friends. And then, when basketball season started, that sort of brought me closer to players on the team who were white, and we became friends. They'd take me to their house, and we'd go out to eat. I remember one, he was a senior, one of the football players in the school, and he used to tell people as we walked down the halls, 'Don't bother this guy because he's my buddy.' He sort of helped me bridge some things and eliminate some of the problems I was having.

"I would catch it at school with the teachers and the students, and then I was catching it in my community. After one game I didn't have a ride, and some cheerleaders brought me in the

neighborhood, and that started a lot of friction with the black girls and incurred a lot of problems.

"The only thing I really had was athletics, and that sort of helped me to stay focused, but I got it on the athletic field, too. I played basketball, football, and baseball. I could be on the baseball field and we'd go in a certain neighborhood and I'd be the only black on the field, and they'd call 'Tar baby,' and, 'Black boy, go home,'—fans, and from the other team. But it motivated me, made me hit home runs and score more points. I guess I was the right person for the situation. It's like I was called for that. I had to stay and take the hits. It was an experience I had to deal with, and my parents didn't really come and ask me, 'Do you have problems with this?' It was, 'Go get 'em boy.' They just figured I could handle it."

Bob Gossett: "I remember being afraid to drink after a black person. I don't know where that came from. Maybe it was just a subliminal thing, the message of separate water fountains, separate bathrooms, that if I took a drink of water out of the same cup or ladle—we didn't have squirt bottles then—that somehow I would change or something funny would happen to me. But my experience with Buster was such a positive experience, and the experiences with Foots and with Greg were also positive experiences. So it was sometimes kind of perplexing.

"When I look back at it now, seems like, how could we have had a society with those attitudes? How could *I* have had those attitudes? In today's society I relate homosexuality to the skin color issue. I have friends that are homophobic. I can remember people at the church [saying], 'There will not be a black man coming in here,' and sometimes they were not kind. They would use the 'n–' word. Why? Fortunately, the minister grabbed a hold of it and took care of it."

Chapter 4

Race: The Immigrants' Perspective

Hollywood has rich, diverse neighborhoods attracting people of various racial and ethnic backgrounds and age groups. French Canadian restaurants and music have transformed the Broadwalk along Hollywood Beach. An influx of Cubans began around 1960 in Broward and Miami-Dade Counties and Puerto Ricans, Dominicans, and now South Americans make up a sizable portion of Hollywood's Hispanic or Latino population, opening businesses and professional offices. While the Spanish-speaking population is steadily rising, there has been a slight drop in black residents, and as Money *magazine points out, African Americans live in only a few neighborhoods and aren't well integrated into the overall community as Latinos are. Some Caribbeans are moving in as well, and they encounter less problems. Both Latinos and Caribbeans recall experiences that have made race relations an issue for them in this country, if not ever before.*

Diana Wasserman Rubin is Cuban and a longtime Broward County School Board member and South Broward resident. She arrived in Miami Beach in 1960, just in time for the Civil Rights Movement and its effects over the next few years, even on a teenaged immigrant girl: "One of my friends is mulatto—not African American, but Cuban-mulatto, a mix of black and white. Mestizo is black, white, and Indian. There are a lot of mulatto Cubans—lots. She came up with the idea that, having seen some of what we were seeing in the current events, that we should do something about it other than just pray. I mean, praying was nice, okay, but I remember she was like . . .

83

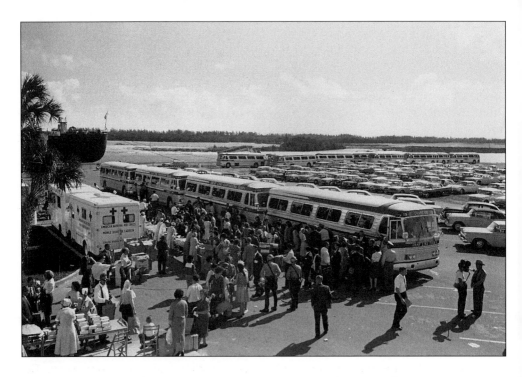

Cubans arriving at Port Everglades in 1960

always starting something. And I wanted to be a part of this. It was going to be sort of like a social conscience group of some sort that we wanted to, at the age of 15, 15 to 16, we wanted to do something to help in the cause of freedom and rights and all that.

"I went home, I remember I was so excited. I tell my mom, 'Mom, I'm going to get involved with it.' She says, 'No you're not! People get arrested for these things. Look, don't you watch the TV? People are getting beaten with sticks, and I don't want you to get hurt, and I don't want you to.' And I remember her clearly saying, " . . . I don't want you to ever, ever, and remember this, be involved in politics, conversations about politics, religion, and race. Don't talk about it; don't get involved. This is not our country. People get picked up, and then we won't know what to do, and we're trying to make ends meet. Please, you have to make us proud, and you have to get an education, and don't get involved with social things.' I respected my mom, okay. And I feared my mom because my mom had a heavy backhand, all right? [But] that is exactly the direction that I took. Who I am today is because of my involvement in all these issues. So, I'm sorry, Mom.

"There was a time when I called her, later on in my adult life. I was already elected, so I was already a public person. And I said, 'I thought I would tell you before you find out. I'm going to Tallahassee because I'm going to fight for the [Equal Rights Amendment].' I explained the ERA to her, and I was fearful. I was already a married woman with children, and I was afraid that this woman would reach through the phone and choke me. I said, 'And do you know what the ERA, Mom, is?' She said, 'No,' and I explained it to her. 'It's about women's reproductive rights.' Silence at the other end of the phone. And the next thing she says is, 'Good for you.' We never talked about sex. I never knew how she felt about it because that was part of the culture, but after I was an adult, she was able to share with me that she supported women's rights. I never knew that. So, anyway, back to the Civil Rights Movement. She was petrified. We were working on our residency and our green card. I mean, imagine if we lose, and they send us back to Cuba or something. She lived in fear of that.

"So, my contribution was that when my friends were having meetings or we were collecting money to send to the Civil Rights Movement, what I was good at was painting and decorating, so I did the posters. That was my contribution, saying, 'Come to a meeting,' 'Equality for all!' I made the posters for it, but I wasn't allowed to go to the meetings, so I wasn't a participant. But I felt as though I had done something. We discussed these things ad infinitum [in Catholic school], the inhumanity that was going on, and how was it possible that in a little island floating in the Caribbean, like Cuba, we did not feel or do to our own people what was being done to native-born people who were born in this, the biggest, the most wonderful country in the world? 'Cause that's the vision I had of the United States. It is 'IT.' It's like, the best. Here I am, floating in the Caribbean, coming here, and seeing that there were separate places for blacks to eat, and the blacks had to sit in the back of the bus.

"I took the public bus to school, and I took the bus to go shopping, and I remember the blacks in the back. And we discussed that in school because, if we hadn't discussed it in school and I don't hear anyone complaining, it wouldn't have dawned on me that this is a calculated thing. They just came in, and they walked to the back of the bus. The separate water fountains, it said, 'Colored only' or 'Whites only.' When I came home and discussed these things

with my mom, my mom opened up to me. [She] and my father were a professional dance team, my biological father. And they used to come to this country when I was a baby. I had a nanny that traveled with her, and she was black—Cuban-black. She used to go up to New York, and she used to go to the Catskills, and she used to travel through the states. And they wouldn't let her sit and have a sandwich next to my mother at a counter, and my mother refused to eat there. So my mother knew of this but never shared it with me until I came home and told her we were discussing it. She encountered that. It wasn't until I brought up this disturbing stuff that I was learning about this. [Things in] my adoptive country that I really hated. Mercedes was like a part of the family, and she wore a uniform! I mean, that was just the way it worked.

"I had my girlfriends in high school, and we went to parties together and stuff, and in college I had a friend . . . but . . . you know what? She was a Hispanic black; she wasn't an American black. Theresa Martinez was her name, and she and I became very close friends, to the point where I would go to her home for dinner, [and] she would come to mine. But then again, it was still familiar to me because the language was Spanish. You're making me go back to an actual relationship. She was Puerto Rican-black. I was in my first year of college in downtown Miami, and she lived in, I think, what is considered now Little Haiti. She talked to me about the fact that she felt discriminated against on two counts: the fact that she was Hispanic and the fact that she was black. I didn't feel what she was feeling, but I was listening to what she was feeling, and I was not experiencing it but hearing it from someone who had. We used to talk about it a lot, but it came to a point in our relationship that we didn't talk about it. We just *were*.

"Oh sure, people looked at her differently. People were more apt to come talk to me than to her in a social gathering or if we went to a restaurant. By that time, though, I don't recall there being segregation in the restaurants. So, it's a little bit different then. We went to, not a nightclub but a dance club, down where she lived in Miami somewhere, and I remember being maybe one of two light-skinned people in the whole place. I think the reason that I don't remember being ostracized, other than the fact that it was very easy for me to find the other two, is because everybody was either Cuban, Puerto Rican, Santo Domingo. I guess that indicates to me that where you come from has more to do [with it], in terms of relationships and the color of your skin. That I am primarily a Hispanic, number one, and secondarily a Caucasian. Isn't that interesting? I hadn't thought about it that way, but that's why I felt comfortable there. Everybody was 'Hey! How ya doing?' 'Que Pasa?' 'Que Pasa?' It was obvious that I was one of three, but I did not feel discriminated against."

*R*amon Torres came to Hollywood in 1967 and operates a hospital equipment rental business with his wife. A medical doctor, he fled Cuba in 1962 at 30, and he started over in the U.S.: "I was in one of the hospitals; I was the administrator over there, and here come about four or five [men]—one guy was Ché Guevera. He was a medical doctor. He said, 'Where are the keys?' He said, 'You want to work for us?' I said, 'I think I want to take a little rest, and after that I will come and talk to you.' They escort me to my car, and that was the end. My adoptive mother and two sisters, they leave first. After that, my father and I, we can't leave because he was a medical doctor, and I was studying. We start looking for a way

Cubans line up for processing

to leave. We keep trying and trying and trying, and at last, one day, we was ready to leave again in a little boat from one of the ports over there, and one of the patrol boats came around, and we had to go back. About two days later I had a ticket to a flight to the United States. All my papers was false papers. The day you leave, all [your things] have to be [left] there. I take two shirts—what I have on me plus another shirt for work, one extra pair of pants, one extra underwear, and one old pair of shoes.

"When I came from Cuba, I went to Miami, and that was the time they tell you there was too many Spanish people. You have to leave the area. And one day they called me to the Refugee Center and said this is your ticket—you're going to Kansas—and they put me on a plane. I was in Kansas for five years; I think it was for five years.

"When I put my feet over here, the first thing somebody told to me, be careful because the blacks think we come and take their jobs away, and they are mad with us. But I didn't have any problems with anybody. As soon as I put my feet in Miami I started work right away. The first place I started working in Miami, I was working with a lot of black people, and we were friends. They know right away I didn't come to harm anybody. I was working for my living, that's all.

"I call the United States like a little cold. [In Cuba] it was more warm. In here, I say, Gee, these people don't have any hot blood or something. They come and tell you real easy you're fired and you don't have no more work, but in Cuba, before that people come and talk to you and say, 'Let's see what you can do,' and [they] don't leave you hanging. Over here, they fire you, and that's it. That is your problem. [In Cuba] the boss is like your friend, your family. You went out; you went to party together.

Over here, the boss sometimes he think he's too much different, you know. Over there, anybody hungry you come and give a plate to eat. Over here, you don't see that. Maybe it's because it's a big country, different cultures.

"[Also] this was completely different from where I grow up with the black and white together. [In my family] towards the black and white, it was the same. Nobody say you are black, I am white—but for some reason everybody want to be on his side. The black, they marry the black girls; the white, they marry the white girls, but nobody told them you can't do that. It was a natural thing. But when you go to have parties, everybody was together. Only the high society have their private clubs.

"I never have problem with the blacks; I never have problem with the whites. One of the first bosses I had over here was a black. We was really good friends. Every time he said, 'We need you to work overtime,' I say yes. We used to run around together—he used to go out with me. We used to go to a bar in Dania, and he used to take me to work. I never had problem and with the whites, the same thing. As a matter of fact, he used to be bad because he used to tell me never to get involved with a white girl because they have problems. You get involved with some black girl. I meet [my wife] in hospital when she come to apply for a job. Before that she used to be in Kansas about a couple of hundred miles from where I used to live. She is German. My family want me to marry a Spanish girl. They tried fixing me with my mother's hairdresser. My father don't say anything. My mother, no. She said 'Give me time to adjust.' Her family was almost the same. Now it's funny. My mother say to me, 'Someday you leave this girl, she can come and live with us, but you can't come over here,' and her mother is the same.

"I think [Hollywood] change in a lot of ways. In Hollywood Hills, we have a lot of blacks moving over here. Before, we didn't have any. I think it's because they getting more and better positions at work, and more people come out from school, and more people with professions and making better money and they can afford a better place. And Spanish, too. When I came [to Hollywood], I remember we was bringing a car, and we have a U-Haul-It in the back. We rented a house, and it was not real good, but at that time it was what we can afford. The grass was real high, and I clean a little bit, and I remember when I park the U-Haul-It over there to start taking her clothes out, the first thing I have in back of me was the police. He said, 'Are you new over here?' And I said yes. 'From why you come here?' Asking me all these things. I say, What is this? He say, 'No, I just come to say welcome.' In a police car? That is the first impression.

"We have a big Spanish population now. Now we have a big representation of blacks and Hispanics in employees, not only in the low workers. We have a few people in the higher [level]. In about eight or ten years the blacks and Hispanics will be in the predominant in the area. I think Hispanics the higher, but I see more blacks, too. It's a big change since I come over here. More progress, more money, you can live better."

Paula Tejeda has witnessed other changes as well. The 52-year-old librarian was born and raised in Puerto Rico, and she remembers the lifestyle and attitudes of a firmly established community there. When she moved to Hollywood in 1986, neighbors on her block only showed up from November to May, then fled north to Canada, Chicago, and upstate New

Teenager Paula Tejeda (right) and her family in Puerto Rico

York: "[In Puerto Rico] we lived in the countryside, just five minutes from my hometown, the second oldest town. The area was farmland—sugar cane. Most people who lived there owned the land and were my family: first cousins, second cousins, uncles, aunts, second aunts, great-great aunts. It was very family-oriented. We went to school, which was next to our house. One of my father's uncles donated this house to the school system. So my sister, brother, all the kids in the neighborhood and I went to that school. Then, I went to the city to attend school. In the afternoon after dinner, around 5 o'clock, we all would go for a walk. We were joined by the other people in the neighborhood, and we had a lot of talking. Sunday was a special day, family day. We would all get together at one of our eldest aunts'. First they pray the rosary. Then, all the women would sit in one area and chat. All the kids would be in another area. One of the uncles would make ice cream in one of these ice-cream makers, and we all had to help. If you did not help, you didn't get ice cream. Everything was family.

"I was supposed to be a well-behaved lady. I was supposed to go to school and study and be a professional—the medical, the doctors, lawyers . . . at the top, [the lower] perhaps, a mechanic. Probably, someone who didn't go to school, though they could have a good position in their jobs because of the way they performed. In school, first grade through twelve, education was excellent. So, when you finished school you knew a lot, and you could perform well in any job. When you have to get an education or degree or some type of occupation, that would make you look

better. It was something important. I think it's still true in Spanish countries. You're valued by what kind of education you have or how high you got. The high society people, the mid-class, poor people or low economic class—I remember seeing these three different levels. I was fortunate because when I moved from the school in my neighborhood to the city, my father registered me in the Catholic college. So, I had the opportunity to get together with the two higher levels. Then, when my brother and sister were ready to go to school in the city, we all went to the public school, which was excellent at that time, and still there were three different levels.

"We were always taught that you should never refer to a person about their color or any other special handicaps or special physical things. That you respect people. You don't call the people "black" or "negro" because that's offensive. Yes, I could see that there was some type of differentiation, but in my family I always learned that you respect people. It doesn't matter how they look or how they are or who they are or where they're coming from. [S]ome of the older aunts who were my mother's or father's aunts and uncles, they were more into the Spanish influence than we were. Probably because of that they would make some comments about some black people or others on a lower level. But, on the other hand, they were always teaching us to respect them. That doesn't mean that they are less than you are. That's something I don't understand.

"I was in college in 1964, so we were aware of everything. We had some people moving back to Puerto Rico from New York, and the eastern states, and they brought with them those changes and concepts. People began to feel more liberal, with the right to go against what was established at some point. We could see that in the politics, also. Actually, what we saw was a group of kids coming to school with different ways of valuing things simply because they were already into the changes of the '60s. Some of them had already embraced those changes. They would probably behave different in social manners—sexual relationships, certain behavior in a romance. They would come with different views than ours. That was a shock, somehow. Some of our parents would say, 'That's a no, no for you.' That would not be because of their color but because of the way they were raised or the things they believed could be or not be done, which was not according to how we were raised.

"There was a time that many people were coming to the states. They were called migrant workers. There was another group that came to pursue graduate degrees. Most of us would go to our universities. There were a lot of universities in Puerto Rico. Within my family, everybody except for three of my aunts from my mother's side—no, two aunts and one uncle—they came to New York, and they're still there. My uncle went back to Puerto Rico and passed away there. They moved here in the mid-40s. But on my father's side, everybody stayed in the same town, same neighborhood. The first generation that got married out of that circle and moved to other towns or other places was mine. Very few of the older ones were living in a different area.

"I married a person that nobody knew. As long as they like him, there was not a problem. He was also family-oriented. I don't think any of my cousins had a problem with whom we chose to marry. My father and mother and aunts and uncles were very open-minded in that way. They would encourage family activity, but they were also very open-minded about that. My cousin was going out with a boy who was a darker color.

Paula Tejeda

Paula Tejeda and her family in the Dominican Republic, 1984

"My husband [a Dominican] got a contract in the Dominican Republic, so it was my husband's turn to live with his family. I got two part-time jobs. We lived there from 1981 to '85. Then, we decided it was time to move, explore other worlds, so we decided to go and see the United States. We visited to friends in Florida, probably because it was so similar to Puerto Rico.

"My first time [in the U.S.] was in 1969, to Washington, D.C. with a cousin. The first advice that we got was from my friend going to college with me. She told us, 'This is the bus to go to Washington. This is where you stop. This is what you do. But don't speak Spanish once you get on that bus, and if you see any black people sitting on the bus with you, don't talk Spanish. Don't look directly.' It was just a year after the big riots in Washington. All the area was burned. People were living in tension, and it was very sad. I mean people telling you that you get on the bus, and you have to be careful about this because of all the people sitting next to you. First of all, don't speak Spanish because they will think you're talking about them. It was very tense.

"We lived in Puerto Rico or the Dominican Republic where my husband is from, and we lived for five years. We traveled many times before we went to live there. You have a neighborhood and half of it is a darker color, while the other is a lighter color. There's no difference, no segregation. When we first moved [to the U.S.] we lived in Hialeah, and we had to go register the kids and have them checked and get their shots. They explained to us how to get to the place, but we got lost. We were right in the center of the northwest area in Miami, Liberty City. We could not believe what we were seeing, the segregation, how neighborhoods changed. You could see that there were only one kind of people living there, and that was not what we were used to seeing in our countries. We couldn't believe the deterioration of the houses, how dilapidated some of the neighborhoods were. If you drove through Puerto Rico and found a poor area, you would find all kinds of people living there. If you drove in the Dominican Republic in a poorest area of the city or any part of the country, you will find black people, white people, mixed people living in that area. But not saying, in my town the poorest area was where the black people were.

"Hollywood was a small town. The houses were cheaper [than in Hialeah], and we could get a nice house in a safe neighborhood for half of the money. It was more like a real American city. Hialeah was very Hispanic, already. We wanted a change. For many years we used to go to the mall or the beach, and we would hear all kinds of languages,

but very few Spanish. We were forced to speak and to learn how to listen to English. For the first five years it was that way. Half of the houses on this street were closed until November. Most of the people—and still now, but not that much—but most are snowbirds from Canada, upstate New York, Chicago, only from November through May. So, it was very quiet. After November, you would see all people walking around, and they were very friendly. Then after [Hurricane] Andrew everything changed. The face of Hollywood changed. The people you'd see at the neighborhood grocery store and mall started to change. More Hispanic people, American, Anglo, also. But you'd see them all year. Places are more crowded all the time.

"We still have the people coming from Canada in the apartment units that were all owned by Canadians. We have two or three houses that remain closed [in the summer]. But, after Andrew, the apartments that were closed now have people living in them all year round. We had friends that wanted to move here, and we would go to find an apartment or house, and they would only rent it to you November through May, not the year round. They would make more money that way.

"I hear from many people how they refer to the different ethnic groups or cultural groups like those are Cubans, or Puerto Ricans or Colombians. I hear how some people refer, for example, saying they will only give a job to a Cuban. They will only help the person because they are Puerto Rican. But in the groups I'm involved with, we all work together. There is no difference. We get along well and try to avoid establishing the difference—you're Cuban, you're Puerto Rican, you're Colombian, or you're Dominican, or from Peru or Columbia. No, We try to work together. That

A Puerto Rican flag at the Hispanicfest in Hollywood

doesn't mean that it doesn't exist. You hear people making comments.

"I've known [different] people from the city of Hollywood and friends of my two sons; they were in school with them, and they still come here [saying], 'Mamí, how are you!' My sons learned to live with all types of people, not only in Puerto Rico, but also in the Dominican Republic where you could see that mix more than you would see it in Puerto Rico. So, there is no difference for them who was going to be their friends or who they would bring home. Most of my relationships are with Hispanic and white Americans at work. But we do have many African Americans that work with us, and we have a lot of contact with them professionally. But my daily relationship is with Hispanics.

But if I go outside of my family life, I have a mix of relationships. In my involvement with the Hispanic Affairs Council, I have seen how the city authorities have acknowledged that there are different groups. They have worked with us. They have the African American Affairs Council and the Haitian Affairs Council. I have seen them work together."

Evelyn Baez-Rojas, a clinical psychologist and native of the Dominican Republic, sees subtleties of race and color prejudice that still concern her, however: "I was born into the dictatorship of Trujillo. He was killed in 1961, and we came shortly thereafter. Part of the fact that my father couldn't leave earlier was that he had been blackballed . . . and he had lost his job in the Marine Corps, and that's when our financial difficulties started, maybe three years until about '63 when we left.

"New York offered me material goods from being able to get a bicycle to having a couple of televisions at home to having all the comforts that I didn't have in the Dominican Republic. It was lonely, but school sort of made up for that. School was such a happy place for me. Even in cold weather, I'd be the first in line. There was this Puerto Rican girl that also wanted that spot, and each day we got there a little earlier. I remember just freezing to death so that we could be first in line to go into the school.

"My husband is a physician; he's Dominican. I met him my first year in college—he was related to a neighbor—and we married in 1973 right after college. I worked [in the Dominican Republic] for two years until he finished [school], and we returned [to the U.S.]. We loved the [Florida] climate . . . and it seemed we could move. Factors came together. We moved [to Hollywood] in July of '92 just as hurricane Andrew hit, and found this big home for four girls and my mom and it was just right. [In New York] we had moved to the suburbs for about seven years. It was a small town. We encountered a lot of racism there. Back then, in that small town, it was Italian and Irish people, working class, and my two oldest girls were mocked and made fun of. Yelled at. They all knew each other, and we were definitely not welcomed. It was a very white town. Besides an Indian family from India and then a Puerto Rican, in the classrooms that I was aware of just going to the functions the number of blacks and Hispanics were minimal—the bare minimum. It has to do with the color of their skin and the last name. I think the name Rojas just didn't do well for them; it didn't matter that we were professionals. It was very hard for my kids coming from Manhattan and public school. We liked the fact that [Hollywood] was a little bit of a bigger city.

"The lady that built this house told me that the neighborhood was changing. She emphasized not the racial, ethnic piece to it, but the years. This is how she couched it: 'More younger people are coming in with younger kids. My kids are all grown, and the neighborhood is changing.' She said that just a few times for my ears to perk up. I drove around, and then [a black man] who lives two doors down . . . I wanted to ask him about the neighborhood. He had moved there two years before we did, and he said it's changing ethnically, but it's stable. He talked about the school system, and he gave me tips about how much to offer. I liked the fact that he was living there.

"In the Dominican Republic there has always been a striving to be whiter. People want to marry people that are light-skinned, straight hair. I have this one grandmother who was always with a brush after me 'cause my hair is so

curly. And she would say, 'Why do you have kinky hair if everybody in the family has straight hair?' I grew up with that complex. To this day, I blow dry my hair. However, there are a lot of people in power who are dark-skinned. And so there is what I would call an aesthetic desire for the white race, but blacks are equal in intelligence. Of course you want to marry white; you want your children to have straight hair; and the family members that are light-skinned and blue-eyed, they are deemed beautiful—not smarter. I was always thought of as very, very smart in my family. She's not pretty, but she's smart. Compared to other relatives, I'm not considered white-white. My skin is wheat. That's what I am considered. My nose is not straight enough and my hair is not straight enough to be white. My first cousins range from very dark-skinned to blue-eyed blonde hair, so I'm sort of like in the middle.

"My grandmother always said, 'It is better to marry a black professional than to marry a white garbage collector.' And I'm quoting here. So I think there was this high value placed on intelligence and achievement. To become a professional; to be married to a professional. So, of those two, they would choose the black professional, not the white garbage collector: doctors, lawyers, architects, lab technicians. Anything that was a trade that earned a living.

"I've become aware of race relations changes through my kids. I have those remnants of having a pretty nose and straight hair, but I would like for them to marry someone who doesn't have a flat nose or kinky hair, and they say, 'Mommy you are so prejudiced.' They are wonderful kids and they have a good mix of friends, and the schools are a wonderful mix. My oldest daughter had a Dominican boyfriend who is dark-skinned, and I just wish his nose wasn't that flat. I kept saying that, and she said,

'Mommy, how can you say that? Why is that important to you?' And I can't answer that. I'm so old world. You know how when you have anorexia and you see yourself as fat? I haven't been able to get that out of my head. My kids are good for me in that way. They're very good for me. They're very open. But, like my grandmother said, I'd rather have kinky hair and black if he is a professional than a non-professional."

Pedro "Peter" Hernandez Jr., 37, has lived in Hollywood for 25 years. He came to United States from Havana, Cuba, via Spain when he was around 12. He talks about his childhood memories of being a new immigrant learning about race: "[My memories] are bittersweet. I have very good memories of running around and playing with my cousins at my aunt's house. They lived in a two-story house that had a big terrace, and we would play out there. I also have a memory of my birthday because I was born into the Communist regime. We were given a *libreta*, which is a book that told you how much food and when you can have it and how much meat and how much milk. One of those things that I found was the highlight of my life was that you would get a six-pack of soda on your birthday. On my birthday, I went to the store with my book, and the guy asked me, 'Where are your bottles?' I didn't have any bottles. They were so mean-spirited, enough to put the sodas out of the bottle into a bucket and actually handed me the bucket. I was dumbfounded, but I was a kid and I went back home. So, when my father saw what they had done, he says, 'You wait here.' He went back and I don't know what transpired between him and the store owner, but he came back with a six-pack of soda in bottles. That's one of the memories I'll never forget about Cuba and how mean-spirit-

Peter Hernandez, age 12, and his family

ed the people can be towards children.

"But, overall, I have very good memories of Cuba. We were in need. A lot of times most of the things that we did to survive, to be able to eat, was in the black market. That's the only time you would be able to have meat and milk for your kids. Both my older sister and I went to school, which was very rigid. You had to go to school. After school, my mom would always be home. It was good. We had a very bonding experience. My mother worked, but she always managed to be home. My father was always in construction. He worked as a plasterer, so he was very fortunate that his skills landed him on a cushy job towards the latter part of his stay in Cuba. He was being paid by the government as he was working for the Minister of Commerce helping this gentleman finish his house.

"It's funny. In Cuba we didn't have a racial tone as far as discrimination toward one another. Everybody was Cuban. We referred to the African American as *negrito* or *el mulatto*, which is a light-brown African American. But they didn't have racial overtones. It was just a matter of descriptive. I didn't feel there was any animosity towards African Americans, at least in my experience. We moved around in different places, and in the apartments where we lived there were African Americans as well as whites.

"I don't remember taking anything with me. I don't think they let us take anything. We took the memories that we had. We went to Spain and lived there for about 24 or 26 months.

Then, we came to the U.S. My dad's brothers lived in Hollywood and Fort Lauderdale. They were working in construction. They weren't Dade County Cubans, for some reason. They were some of the few pioneers that moved to Broward County because they were here years before we arrived, and we've been here for 25 years.

"We arrived at Miami International—Iberia Airlines. My dad's family was there, which I barely remember. My Uncle Luis had a 1963, four-door Cadillac. You would only see those in a wedding, and in the seventies, this car was about 11 or 12 years old, but to me it was like, wow. As we were driving back from the airport, the weather was humid and hot and his air conditioner didn't work, but the breeze was coming in. I just felt that it was hot. A few days after moving in with Uncle Luis, his wife and two daughters, I got a used bicycle. I rode that thing until I was crisp. I was so sunburned it wasn't funny. It was the first bicycle I ever had. The language was a major barrier. I couldn't understand what people were saying to me, and I couldn't relate anything that I wanted to say to anybody. There was one other family. I met the kid in school, years later. There were two grocery stores. The Spanish were spread throughout Hollywood. There wasn't one concentrated place that they lived.

"We arrived during the summer, so I didn't have to go to school until the fall. My dad dropped me off at the school, and I didn't know where to go. I saw all the kids outside, and the doors were locked. The bell rang and everybody went in, and I'm standing outside saying, 'Where do I go?' I didn't speak any English at the time, so I went to the principal's office and tried to talk to somebody, and they didn't know. Twenty-five years ago, in 1974, this school system was not set up to take children who did not speak English. I went to the office, and they tried to come up with somebody who would translate for me. They didn't have any teachers. They came up with this kid, Warren—he was of Mexican descent. He was a piece of work. I learned kids are cruel. Although Warren was very helpful and instrumental in me trying to go through the classes, it became obvious to the school that I wasn't going to be able to go through classes with Warren. He was a child, and he couldn't relate what I was trying to say and what the teacher was trying to say. So, my learning would not take place.

"I was labeled 'LD,' learning disabled. I was put in a class with what some people might call 'misfits.' But, in my case, they were kids that were different, and I felt right at home because I was different. At the same time, I had the same classes that everybody else had, but then you would cut off early to go to this class with this group of people. I would sit in the classes, but I couldn't figure out what they were saying. Math, I did, because numbers are universal. But as far as history and social studies, it just wasn't there. Within three months, I was speaking English. I caught on quick, and the accent was getting better and better. I learned early in life that if you want to be successful in life, you have to blend in. Even today, I go to Miami in the truck, and when I speak Spanish people say, 'You don't look Cuban.' I say, 'What does a Cuban look like?' I have cousins with blonde hair and blue eyes and cousins that are African American. So, what does a Cuban look like? I never get a response to that question.

"The school was divided between whites and blacks as far as the sports they play and the hangouts. The blacks would hang out with blacks and whites with whites. As I grew into the system, I realized that there was racial tension between whites and blacks.

Peter Hernandez Jr.

They called me something I never heard before—a 'spic.' I asked, 'What's a spic?' and they said, 'You're a spic.' I said, 'Yeah, but what *is* it?' I wanted to know what it was that they were calling me. Although they used it freely, they didn't know what it meant. So, I was an outcast as well. But I was more tolerable to go back and forth, to blend back in, and I blended in with both groups. I had African-American friends and American friends. I blended in and played with everybody until it came to fighting. When it came to fighting, everybody seemed to pull for their own, and I was left out in the cold because there wasn't a population of Hispanics. So, I would get into fights everyday with African Americans and whites. They would tell me the same jokes or play the same pranks as when I didn't speak the language. But by then, I did understand what they were saying, and that would create a confrontation. They'd call me names. They'd call my family names. They'd call my mom names. When you don't understand that, you don't know. But when you do, your blood boils, and those are the confrontations we had as children. I didn't know, then, what was happening. I was 11 and a half years old and didn't have the grasp of what I was experiencing. I'd like to thank those kids because if it had not been for them being cruel, I wouldn't be able to speak the language and blend in as I do. I have no animosity towards them. I would thank them.

"[Eventually], I discovered some other Hispanic kids in school. I remember this girl, Barbara, the first girl I ever kissed. Hope her dad's not mad at me. There were other kids, but I didn't find them for weeks, seems like months. When I went back the second year, there were more Hispanic kids. We were all scattered. I see some kids in gangs because they call that their family. We all had our family at home. There was an Hispanic club in Davie where families would go and play dominoes and other activities. There was the American-Hispanic club in Miramar. My parents ran the kitchen because they didn't have anybody to run the kitchen. My mom is a great cook, and my dad is good at mingling with people. So, we ran the kitchen, and my sister and I both helped. That was some of the evening and weekend activities that we had, manning the kitchen.

"I was involved with the community. I played baseball. When I signed up for baseball, they didn't have anything in Hollywood . . . so, I played in Miramar. Our team was lousy. We were all kids that couldn't hit a ball to save our lives. But the one day that we played our school, we beat them. So, when I went back to school, the kids were resentful about that, and I was gloating. 'We couldn't beat anybody else, but we beat you,' is what I told them. 'You guys gotta be worst than we are.'

"I would translate for my parents. I would have to think in one language and translate into the other. I wondered if it would always be like that. Would I have to take it from the English and translate it to myself in Spanish. One day, I dreamed in English. Ever since that day, I haven't had to translate anything from English to Spanish. For the language barrier, that was the day that I no longer had to have dual minds, one with the input being in one language and the output being in another. It would just flow from then on. Kids are extremely adaptable. You put them from one environment to the other, they miss the environment for a little while. But after a certain time, you see them blend in and focus. I didn't have any problems blending in aside from the language barrier. Other than that, we were just kids.

"It seemed to be apparent blacks were picked on more. I was

still considered to be a 'spic' for some people, but I had become friends with the people that I went to Apollo Middle School with, and they didn't call me [names] anymore. They resented the older kids in high school picking on me. I remember [one boy] standing up for me to the bully in school. We were in the locker room changing clothes, and the guy pushed me, and I automatically pushed him back. When I turned around, I saw this big guy—a body builder—coming towards me to hit me. I pushed him, and he landed on the other side, and Phillip came and stood behind me and said, 'Hey, you pushed him. He pushed you back.' Nothing happened, thank God, because the teacher was around. But I've always admired that about [him]. He was white.

"At the same time, in middle school, there was a black kid, and whenever I had problems with the blacks, he would step in and say, 'No, he's my friend.' And I would have no problems. So, I've always made friends with people, no matter who they were. When you become friends, race doesn't become an issue. It's just person to person."

Helena Ash, 52, was born in Nassau, the Bahamas, and raised in Hollywood's Liberia area, where she still lives. She had similar problems as an immigrant, too: "My parents made sure that we all traveled on the same religious road. We all went to the same congregation. They didn't have much money, but they would load us up in the station wagon and take us on rides for ice cream in Miami Beach. We did a lot of things together as we were growing up, as a family. My sisters and brothers who wanted to take piano got to take lessons. If they wanted to draw, they got to take drawing lessons. So, even though they didn't have much they made sure that what they had went towards the family. One of the biggest things for anyone who comes from an island is family. I don't know if that's a ritual different from anyone else, but coming from Nassau, they were very big on family.

"I was about five and a half when I first came here. I started at Attucks. I remember going to school and being picked at. That was my first recollection of being discriminated against. I still had the Nassau accent. Most Americans, when it came to the island people, were a bit jealous because they were hardworking people. They stressed education and work ethics. We lived in an apartment for a very short period of time. My parents bought a home where we lived ever since.

"As a child I didn't understand why I was being picked on. I know I talked different from them, but later on, I realized that it wasn't just me but most of the people from the islands who still had the language difference or spoke with an accent. But also, they always thought that we thought we were better than anybody else. Foreigners come over and take their jobs and buy homes versus staying in apartments. I used to run home everyday from school until my eldest brother or my mom said, 'Until you stand up, you're going to have this problem.' Of course, one day I finally decided that I wasn't going to run anymore. The problem stopped. I had to fight, but once they saw I was able to stand my ground, it was understood. Then the camaraderie came. But that was a real eye opener for me because I really didn't expect that, all of us being the same color.

"[But] in the community, I didn't notice much of a difference. Most of the [residents] in Liberia were homeowners. As kids, we're going to play. After a while, when everything is said and done, kids go back to playing and

Helena Ash (front row, second from right) with her 6th grade class at Attucks School

Helena Ash (seated, far left) and her family in Liberia

being kids. So, I didn't notice too much of the difference socializing in the community as far as the children were concerned. But I do know that was a problem. In talking to others, later, as to why certain things happened, I found out that their belief was that we thought we were better than everybody else. Coming from an island mostly populated by blacks who were being in certain positions, our parents just stressed education and work ethics. So, education was paramount.

"To be honest, I don't remember any white encounters. We had to go to Winn Dixie to shop, to Kmart, to downtown Miami to Richard's to shop. I guess my parents shielded us from most of that. So, I don't remember the 'White only' [signs]. I know in downtown Miami, when we were getting lunch, you couldn't sit at the counter. But other than that, I don't remember too many encounters with whites and hostility. Most of the time, I just remember them being friendly; even when we were shopping downtown, getting served, they were pleasant. Most of the time, you were going to get what you need and coming on home."

Vera Williams, a traveling nurse, lives mostly in the white world, commuting between Canada and Broward County. She was born and raised in Jamaica and lived for several years in England. She has lived off and on in Hollywood for nine years: "In my district [in Jamaica] there were no white people. We were all black people. But as with every black community, it's like different colors and different textures. People would tend to show preference for this or that color. Or you listen to people's conversation, and it dawns on you somewhere along the line that this is the way it is. Sometimes you would hear people [in Jamaica] say things like they didn't like anything too black. Or, in describing other people they said, 'Oh, she's black and ugly.' Doesn't take long for a child to understand that black is associated with ugly or if you're that much blacker they wouldn't prefer you or they would prefer someone else. The first time I really became aware of how profoundly color could affect you is when I left Jamaica. Although people said things like that in Jamaica, they didn't really follow up with any kind of action that could really, really hurt you. They'd just be talking or someone would be annoyed or upset and they'd say something. The first time I really became aware of how profoundly color can affect you is when I left Jamaica.

"At age 19 I went to England, north London, to join my sister. It was not what I expected. The houses were kind of grim. Everything closed up and gray, sort of. In the Caribbean it was light and airy. If I had money I would have turn around and run. You couldn't miss [the racial climate]. It was in your face—it was very overt racial discrimination. If you wanted to find a place to live, for instance, there were very few places that you could rent. One example of how they advertised . . . and this was in the newspaper . . . the ad would say, 'No Irish, no blacks, no dogs,' and there was no law against it. It was very awful. This was 1962, just ahead of [Jamaican independence]. Because places were so limited, you would have to depend upon a black person to buy a house, and that would become a major tenement. People lived in amazing conditions. Not that it was squalid, but it was so overcrowded. People were living in a room; you would rent like one room, and there'd be like all these families living in this one house because you couldn't go out into the larger society and rent a flat. It got better. I was there for 17 years and, as time went on

Vera Williams with her son in England, 1965

Vera Williams

and people got more accustomed to people, the white people weren't so afraid of the black people—the black people got more accustomed to the white people. People got to know other people. Things got easier. I think independence had an effect on the morale of Jamaicans abroad. Jamaicans abroad, no matter what, they still relate strongly to Jamaica, even though we were expatriates.

"I eventually decided to leave there because even though things had gotten better—we owned our own home and we had cars and we had jobs and we were relatively happy and the West Indian community in England was really strong—but my kids were coming up to a stage in life . . . I struggled with the school system for my kids. I wanted my children to be able to just go to school and get whatever amount of education they wanted, needed, could handle, without having to fight tooth and nail. So I decided to leave, to Canada.

"We lived on the outskirts of Toronto. I loved Canada. It's a big, bold, beautiful place. Now, this is not to say that Canada is perfect because wherever people meet of different races and different colors and different backgrounds, you know there will be still differences. But I can't say I had any real negative racial thing happen. I don't think my children will say that anything happened to them there, either. Blacks and whites kind of mixed a whole lot more than even here in the United States. That's my impression, anyway. People are way more tolerant, I think.

"[Hollywood] was the first place I set foot in the United States. I came down here as a travel nurse, like a snowbird—nursingwise. In the last few years I still go back to Canada, but I'm here most of the time. My impressions? It's a little bit like Jamaica. That's what I find sort of homey about it. Similar in some ways—the climate is great. I was protected from [the racial climate] because when I came here I didn't have to go out into the community. I didn't have to go look for housing. I didn't have to find my own way. We were housed by the hospital. We were provided with whatever we needed. But the thing that alerted me [was] when I met some people and, somehow having grown up in a black skin you can sense attitude, you know when someone has a different attitude towards you, even body language and tone. And I found it astonishing that when they saw me and I was black and I sensed attitude, as soon as I spoke and they realized I wasn't from here, their attitude changed again, and I was really taken aback by that. It became more positive, more friendly. I was astonished because I thought, oh, if I was from here you would have a negative attitude towards me. But I'm not from here, so right away, you have a better attitude. I think a lot of people from the Caribbean have noticed that. We talk about it.

"I get along fine with the black people from here. At work we interact really well. We talk and we laugh and we joke. But something that I've always kind of wondered about is I have friends from everywhere. I meet a lot of people. I'm a friendly person, and I interact with a lot of people. I interact with people from here, but I have no persons from here that I can really say this person is my friend that I've ever gone out and had dinner with or like that—someone who is black. I have white friends that I go out and do things with. I have black friends from the Caribbean that I do things with and so forth. There was a young woman, we were friendly in the workplace, and she kept saying, 'Oh, we should have lunch; we should do this; we should do that.' I said, 'Okay, let's do it. We'll go out and have lunch.' We never did. Every time we would

sort of almost get to the point to have this lunch she never was ready. If a white person and I like each other's company and we agree to do something, we just do it, and if we have fun, we'll do it again, and if we don't have fun, we don't do it again. But it's not hard. There's no reluctance, no holding back, no reticence.

"I know American blacks only in the workplace. I don't know any intimately that I could say this is the difference between us. [But] Jamaicans have a lot of attitude, and for the most part, our attitude stands us in good stead. I think we have to have a different attitude because we grew up in a different environment. For instance, I was working in the same place as a Canadian black woman and a white person who I guess was observing us, she said to me, 'Why are you so different than this other woman attitude-wise?' And I had to say well, I was 19 before I really encountered white people so you haven't really changed me. Whereas this woman, she encountered this race thing from birth. She told me she had to fight everyday she went to school. There was never a peaceful day. And she grew up in Canada. So I guess she has a kind of defensive posture whereas me, I just go there to meet the world. And if you say you're better than me, I say who says so? I don't believe it. I just can't seem to; I can't crack the American thing. That is interesting."

Chapter 5

Voices: A City in Transition

The face of Hollywood has changed on its buildings and streets as the city slowly sheds its small town look for a more modern, cosmopolitan image to match its changing demographics. At the same time, the voices are becoming even more international, and their reflections on the city even more diverse.

Julio De Los Rios, 57, studied accounting and business administration in Peru, where differences in jobs and economics were the determining factor more than race. The 1990s have seen a lot of Peruvian businesses and a growing population. He fled Peru for Hollywood in 1986: "I was working like an administrative manager of five corporations, big corporations. In that time the terrorism was growing. The economic situation was changing between 1970 and 1990, this strong change. It was very difficult for the people to get jobs. I was working in my office with the owner of the company; we received the visit of five people with guns. They hit my face. I almost lost my eye. The telephone system was [tapped]. I decided to come to this country with my family. My wife had parents in the U.S.A. They were citizens.

"It's a big change—the people, the food, the economic situation. It was very easy to get application to get a job. The only problem I had was I didn't get my certificate of accounting in this country. At that time, I did not speak English. My daughter, my son had to go to high school, and I have to support my family by myself. At the beginning, I pick a small business, sell carpet and install carpet in Miami. Then when the business was low, I went to work in [a hotel] in Fort Lauderdale. Maintenance,

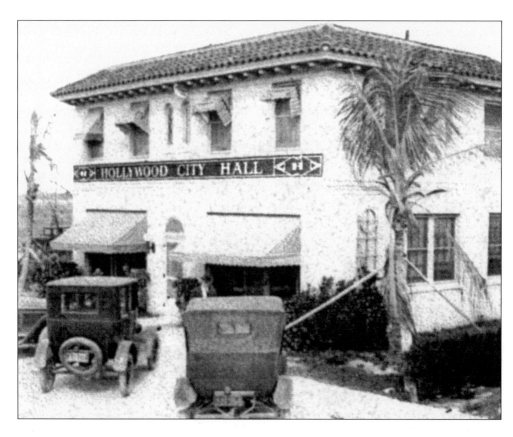

Transformations—Hollywood's first city hall, c. 1925 (above), now a modern restaurant, c. 1997 (below)

like engineering department. I worked for three years. In Lima, it's different than in this country. In Lima there is not difference between races—Chinese people, the Japanese people, the Italian, German, Arabians—a lot of people live in the country. Never I saw any difference between them. A lot of black people, a lot of Indians . . . Jewish people. When I was working in the hotel I saw differences between the white people, the black people, the Hispanic people, first in the positions. The white people were managers; the black people were working in the laundry, the kitchen, housekeeping. The Hispanic people works in the same works like the black people—maintenance. There is not discrimination. It's different treatment the way they talk to Hispanic people and the black people. From there I get a job accounting in a factory, textiles, owned by Chinese people in North Miami and sales representatives from Israel—Jewish people. It was very, very different. The salaries was very different. For that reason, I left from the hotel. From there I get travel agency in Kendall. I like work administrator. Then I got this job in communication company; I am working like auditor, general auditor.

"Six years ago I founded the Peruvian soccer league in Hollywood. With the league I knew a lot of people, different classes, different races—black people, Hispanic people, white people, Jamaican people, Haitian people. I had a good relationship with everybody because I was meeting entertainment with the sport. Now I belong to a Peruvian-American coalition fighting for Peruvian-Hispanic rights. We are in contact with black directors of black communities to work together. They were very interested to work together, but it was a problem, the language; 50 percent, 60 percent doesn't speak English very well. That's the big problem.

"At the beginning, few Hispanic people live in the city of Hollywood. Now our community is growing. The attitude is changing because there is more Hispanic people in this city. When I came to this house, I was the only Hispanic in three or four, five blocks. Now there is black people, Puerto Ricans, Dominicans. It's changing. The other thing is the Peruvian people have demonstrated that they are people with a profession. They have knowledge—hard workers. They put a lot of business in the city of Hollywood. In this area there are four or five restaurants, travel agencies, more stores. There is doctor, architect, engineer, accountant, lawyer, police, a lot of professions. The Peruvian community in South Florida is the second in the best professional starting in the state of Florida after the Chinese or Indian."

Martin Rennalls is a retired teacher and filmmaker from Jamaica—a self-described "white/mulatto" who sees himself as a bridge: "At Rochester Institute of Technology [in 1970], they had a lot of efforts to overcome any form of segregation there. I used to join the colored groups in helping them, but I told them, 'I'm not the person to do it for you because I don't experience it. I know you have a problem, and I'll join with you where I see you want to get change. But I can't tell you that I have experienced what you have experienced.' Until now I couldn't fully comprehend how the black race in America were able to exist and how forgiving they have become. I don't know if I would be as forgiving. I live in a community which is predominantly white, this community here. One or two colored families are in the community. I have never experienced [a racial problem]. I am fully involved in the community, and I have gone through the

community without anybody questioning or making any type of reference to my origin. They only say, 'He's a Jamaican,' [about someone], and I tell them, 'I'm a Jamaican.'

"Racially, I see a larger number of Hispanics entering the neighborhood and becoming a part of the population, not only as house owners but as people in the area of business. I'm vice president of the association in this community. As such, I go to a meeting when all the associations get together. I always make a special effort to invite them to our gala affair every year so, in our community, I can get the black section in Hollywood represented. As I said at the meeting the other night, we don't want to be an isolated community, and if one if one is not careful, a community that is so much predominantly white could easily isolate themselves. It does not breed the good future that we want it to be."

Kee June Eng is a senior management and budget analyst for the city of Hollywood and has become an Asian-American activist in the city, and statewide. He moved to Broward in 1985 from Jacksonville where he came of age with the Civil Rights Act of 1964: "Jacksonville was just a sleepy, Southern city. I grew up in segregation times in North Florida. While the racial divisions were very clear cut if you were white or black, it was less so for somebody who is in neither category. I found it to be rather confusing—traumatic at times—trying to decide whether I was classified in one group or another.

"I never suffered any physical abuse, but there were times when strangers made it a bit difficult. I had friends, black and white. My family has one of the oldest Chinese restaurant businesses, established in 1946, and family members had it before then. So, we're celebrating over 50 years of business in Florida. A lot of our employees were African Americans, and most of our customers were white. So, it was very interesting watching that situation as I grew up.

"[My parents] emigrated from Canton, China. My father came over in the early '30s to make money and send money back to the family in China, as many immigrant Chinese did. But the Chinese people at that time, especially the males, were subject to the Chinese Exclusion Acts of 1882, prohibiting non-family males from immigrating to the United States. So, the Chinese were the only racial group barred from migrating to the States because of these exclusionary laws. Fortunately, my grandfather was already in the country, and he was able to petition for my father to come over. My father came and worked his way across the country at various jobs in the restaurant business. My mother remained in China with her parents, and my father was sending money home to support them. She finally left, just before the takeover by the Communist regime, [and] she came by the way of Hong Kong to the United States to rejoin my father.

"There was a restaurant in Jacksonville that a cousin of ours had owned. He was getting on in age and wanted to get back to China. He was looking for someone to take over the business. As was a custom, he turned to the family. It was in a prime location in the hotel business district in downtown Jacksonville. We had one of the first Chinese restaurants in Florida. So, we had a very interesting clientele come through. It was expected that family members contribute to the welfare of the family, to the family business, by working in the restaurants. I remember many summer afternoons that I would have rather been at the beach or with friends, and I had to stay to actually

Kee Eng (fifth from the left) at the Installation and Community Awards Dinner, 1997

cook, wash dishes, wait on tables, or take cash. So, it made it tough growing up as a normal American teenager having to work in your family's Chinese restaurant.

"Growing up through sixth grade, I went to church school. My parents were converted to Christianity in China and married by a Presbyterian minister. When my mother joined my father, fortunately, they came across a Presbyterian minister who had a ministry in China and took them under his wing in Jacksonville. He guided them to a Presbyterian church, and I eventually enrolled at the church school there. Once I graduated from the church school in sixth grade I guess, for convenience, my parents decided to send me to boarding school in Jacksonville. So I ended up in a private boarding school, the first student of color to enroll in this school. If I'm not mistaken, this was in 1962–63, before the Civil Rights Act of 1964.

"One of the most poignant memories—since we're talking about discrimination and our memories of that—one of the most poignant events [was when] I was in my early teens. There was a group of sailors—Jacksonville is a big naval city. A group of four sailors came in. They were very nice people and wanted to be seated and all that. Three of them were white, and one of them was African American. Unfortunately, there were city ordinances against nonwhites being served in public places.

"You have to understand the situation that my father and his uncle were in when they were working in the restaurant. When we traveled through the South during those times, we never stayed in Howard Johnson's or Holiday Inns because we never knew how we would be received. We never ate

in restaurants because we did not know how we would be received. What we did is, we went from Chinese family to Chinese family and from Chinese restaurant to Chinese restaurant because we knew we'd be accepted there. When we went to Orlando, we stayed with a distant cousin and ate in our cousin's restaurant. In Miami, we tried to find Chinese people that we could stay with. It was a lot easier to travel that way because you never knew if you would have accommodations— which made it even more poignant because we had to refuse service to this gentleman, at least in the dining room.

"I remember we were trying to make every accommodation to serve the gentleman. Take out. We'd allow him to eat in the space where we would eat as workers in the restaurant. Just anything we could. And we understood when they declined. But it was a situation where we would have been violating municipal ordinances, plus the fact that you don't know what would have happened to the white clientele if they had served this gentleman. It was also an economic decision. It was a very difficult situation that we found ourselves in because we understood the plight of the African American trying to be served and get accommodations in the South because we certainly didn't know where we stood, either.

"You know, we never discussed discrimination. I never really did understand, when I was younger, when we traveled, why we always went to Chinese homes to stay and why we always ate in Chinese restaurants. Because I always wanted to stay at Holiday Inn. It would have been neat to stay in a hotel and eat in a restaurant, a McDonald's or a Krystal's or something like that. But you never really knew how you'd be accepted or accommodated at these establishments. So, I guess it was unspoken in our home why we did that.

I never really understood until that particular incident [with the sailor] because my father had to explain to me why he had to do that.

"[As I said] Jacksonville was a big naval town. At a Veteran's Day parade, I'm standing there watching the parade. The next thing I knew, people were calling me 'Jap' and asking me, 'What are you doing watching a Veteran's Day parade?' I was really taken aback. I didn't understand why all this anger, or uproar. A group of white teenagers were making fun of me. Then, it dawned on me that the Japanese had attacked Pearl Harbor and that because of my skin color and facial characteristics they didn't realize that I was not Japanese, that I am Chinese. Trying to explain to them that, excuse me, my country was also attacked by the Japanese empire at that time really didn't strike a positive tone with these people. They really didn't care other than the fact that, 'What's this Oriental, this Asian, this non-white American standing there watching a good-ole All-American Veteran's Day parade?' [At] 10 or 11, you're a kid, and you really enjoy the parade. You watch all the tanks and the military people go by. You are really impressed by all this and to suddenly have this kind of, like, hit you—you are caught very unaware, and it makes you grow up much too early, unfortunately.

"There was another incident that brought back to me the fact that I was not necessarily accepted. I was walking downtown to my family business from the church school. It was a walk of about 15 to 20 minutes, down one of the main streets in Jacksonville. You walk through an African-American community built alongside the train station. I remember some of the African-American children making fun of me for being Oriental or Asian. This struck me very odd because I'm thinking, 'These people are being discriminated against

and yet they turn around and call me names because I'm not the right skin color.'

"My seventh grade year it was tough understanding why my parents sent me [to boarding school]. It was along the banks of the St. John's River, a very old, prestigious boarding school with a lot of very rich families whose children were enrolled. The minister of the church knew the headmaster and suggested that they might consider taking in this Asian child to provide him the educational opportunities. It was not something that the school had to do. It was prior to the Civil Rights Act. It was very courageous on the part of the school I thought, later on, looking back on it. At first, I ran into the racial caricatures like 'Chun King' and 'Ching Chong,' that I heard as I was growing up. I'm thinking, 'I have to go through this, again? Why?'

"One reason—my parents had always instilled in me that I represented not only my family but also the Chinese people. We wanted to do well to leave a positive mark for our people. So, I put up with it. But our headmaster was very cognizant of it. He was sympathetic and invited me into his office to sit down and have a heart-to-heart talk and said, 'Is that bothering you? Should I do something about that?' I said, 'No. It's a hazing, a ritual that I understand I have to go through. If I don't stand up and see my way through it, they will win.' So, he said, 'Fine. But if there's a problem, let me know.' After that, I didn't hear too much about it. Eventually, through weight training [laughter] and becoming a member of the football team, nobody ever bothered me again because I was one of the larger kids. But it was a very interesting time. This was the first time I said, 'I've gotta see my way through this. I'm not going to let that beat me.'

"Growing up in the South, you always saw the colored restrooms and water fountains. I never understood which one was I supposed to use. It helped me build up inner strength as a child to take on these challenges. I'd usually just go into the white bathroom, and if I got thrown out—which I never did, fortunately—I'd be okay. Even though there were no African Americans in the school, there was no hint of racial prejudice. Finally, when I was playing football in the late '60s, the athletic teams in Duval County where I was from were integrated. I made the All-City team, and I was a part of a team of the first minority athletes to be named to All-City football teams. This was a big event in the town because there were several African-American students that were named to the same team. I remember the headline of the article: 'First Chinese, Black athletes named to All-City team.' That was a big thing—at the time. We played against these people, but there was never any type of racial prejudice that I was aware of. So, the school prepared me for different cultures, different types of people that I would come in contact with.

"At our restaurant, most of our staff—especially in the kitchen—was black. I spent most of my time in the kitchen. Some of my most memorable times were hanging around some of the characters that we had working in the kitchen. One of the cooks that my father trained was an African American, Leroy. He had this big motorcycle, and I'd love to cruise around downtown with him. Make my father crazy because he was always afraid that Leroy would crash. I grew up with him, and we talked a lot. I guess as much as Leroy loved to party, he tried to make sure that I didn't get into any trouble. His cousins also worked there. Some of the people that I'd wash dishes with were very interesting characters.

Kee Eng (fourth from the left) at the Asian Arts Festival, 1998

Another person working in the kitchen was a very accomplished vocalist who I encouraged to finish his vocal training and [saw] some of the frustrations that he encountered because he just could not raise enough money to continue his vocal education, even though he was an accomplished vocalist. There was another one, Tony, always in trouble with the law. But my father always took him back. Every time he'd get in trouble, we'd lose him for two weeks or whatever, and he would come back and ask for his job back. My father would always take him back. When we were very young, my father would entrust his children to the care of several of the restaurant people, I guess, on their day off—some of the African-American people. There was a relationship with the African-American community. I remember sitting in a couple of church services when I was growing up. I just remember it was hot. I had this fan and kept on fanning myself. An African-American church—I don't recall the denomination. I was sitting there. It was hot. I just wanted to get out. But it was a very interesting experience.

In 1968, I went to Georgia Tech for about a year and a half to study architecture. As consistent with all immigrant families, they saw education as the key to the future success of their children. Certainly, my father's motivation for coming here was to provide opportunities for his family. He was always stressing education. That's one reason why he was so eager to send me off to boarding school, even though $5,000 or $6,000 a year back in 1960 was just a huge sum of money for a working couple. They were very eager to give me every educational opportunity. I was the first college graduate, and I have to give him credit. He was very proud. He wanted me to continue my education if I wanted to go on to graduate or professional school. Honestly, I looked at it as getting out of working in the family business or getting a regular job. So, I took him up on the opportunity

and went on to get my graduate degree and my law degree. He's extremely proud of the law degree. He actually closed the restaurant down, came up to New York, and we sat together in Avery Fisher Hall at my graduation ceremony from law school. This was one of the high points, I'm sure, not in my life but in his life.

"At Georgia Tech, my thinking was more an American kid accepted into a prestigious university. Your whole future is ahead of you. But I got slapped back into reality when I went to fraternity rush. The word got back to me that there were several fraternities that did not want to rush me because I was not white. But if I were interested in continuing in fraternity life, there were a couple of fraternities that would consider my application. Bowing to the reality of the situation, as opposed to just not participating at all, I went to visit one of the fraternities that had indicated that they would consider me. I came across a brother who was Chinese, from Mississippi no less, Wilson Wong. Wilson took me under his wing, and we got to be very good friends in college. He convinced me that this fraternity was the opportunity to get into fraternity life, if I wanted to. So, eventually I decided to rush them. That was my one big memory of racial attitudes in college, especially at Georgia Tech. I was there for about a year and a half and came home after that. But I always remember Wilson Wong, and I'm appreciative of him. That was a very difficult time, being away from home, not knowing anyone, being a freshman on campus. And to run smack into this attitude, again, of not knowing if you would be accepted as opposed to knowing that you were not accepted so don't even bother. All this uncertainty again came welling back up, and Wilson got me through it.

"I'm sure my parents' values are deeply ingrained in me, as well as the values I learned through the church I went to. But I was in a period where I was disavowing my Asian heritage. I just wanted to be American. All my friends were white. We hung out together. We had similar interests. I was really more into the American culture as opposed to my Asian roots. I've come full-circle, now, after law school and getting involved in a lot of the community activities, especially in Hollywood and South Florida. It's been a resurgence of pride in my Asian roots and my Chinese heritage. I see that even in my children. They are going through kind of the same path that I did. All of their friends are American as opposed to Asian kids.

"I worked with Asian-American groups first, before we started reaching out. The first thing that we needed to do was build up our own community and then start doing the outreach to other communities. The Asian American Federation was organized in the city of Hollywood back in 1984. I remember sitting in meetings with my father-in-law, who was an officer in the federation in homes in Hollywood and later on, when my brother-in-law had his restaurant in Hollywood, we would meet there, and we were just trying to form a nucleus of an organization in the Asian community and gain momentum and support for that before reaching out to other communities of color.

"I started forming working relationships with African-American groups that we had common interests with, like the NAACP. I've worked with them on a couple of things representing the Asian-American community. A couple of the other immigrant-related activities here, where African Americans were sympathetic to the plight of immigrants, we've worked together on that. We work with the Caribbean

people. Haitians. I remember back in the early '90s with the Asian American Federation, which I am president of now, we came out in support of the Haitian migration to the United States. We questioned why the Cubans were allowed privileges under the immigration laws as opposed to the Haitians, the Chinese, or any other immigrant groups, which I'm sure didn't sit well with my Cuban-American friends. But it was just a matter of equity and fairness in treatment to all. That's when we ran into people outside of the Asian-American community.

"It's interesting because the federation itself is an umbrella organization. We were able to identify about 18 to 20 different ethnic Asian-American communities in South Florida. The unique thing about that is many of these communities have had a traditional rivalry or hatred for each other, whether a religious basis or ethnic basis or economic basis. For instance, the Vietnamese and the Chinese in the southern part of China have warred over territorial rights for many years. You have Hindu and Muslim religious sects in India that have killed each other over their religious beliefs. But in the United States, these same people sat together around the table in the federation and discussed issues that impacted all of us. I guess when you're tossed into the same boat, you realize you have to row together to get anywhere. It was very fascinating to work out these issues before we were able to reach out to other people. We had to work out our own internal issues. I remember meeting at a Hindu temple one week; the next week it was a Christian church; the following week it was in a Muslim facility. That's the diversity that you ran into in this federation we created in little old Hollywood in 1984. The original person or people that came up with the idea lived in Hollywood. In 1987–88 it was kind of a sleepy little town. I looked at it as a suburb or bedroom community of Fort Lauderdale or Miami. It was a city in slumber that just had not reached or grabbed for it's potential. It's only recently that it has awakened and taken on a vibrancy and new attitude about what it can do."

Guithele Ruiz was born in Port Au Prince, Haiti, and moved to the U.S. at age 11. A Broward County resident since 1986, she was an administrator for the city of Hollywood from 1993 to 1999 and has watched it grow: "From the time I can remember, I knew school is very important at home. It was just a normal family with mom and dad and my siblings. One of the things I enjoyed was that my grandmother was a big part of our life. We spent a lot of time with her. I remember a lot of Sunday afternoons gathering at her home with a lot of cousins, uncles, and aunts. So, it was almost a ritual for us, every Sunday afternoon going there and eating with her. I also remember Sunday nights; my dad loved music. There was a park in Haiti where they would have big bands playing performances. Very often, we would go to the park on Sundays and have ice cream. That was a very pleasant memory.

"It was a pretty modest neighborhood. We had a more comfortable [home] than a lot of people. At the time, when we lived in Haiti, there was a middle class. I don't think it exists anymore. There are so many extremes. You're either rich or poor. But growing up, I do remember a middle class. For example, my mother was a teacher, and my father was a statistician for one of the governmental agencies there. I grew up to see a lot of my aunts going to work. A lot of the women were teachers, A lot of my aunts taught school. I remember them being very involved

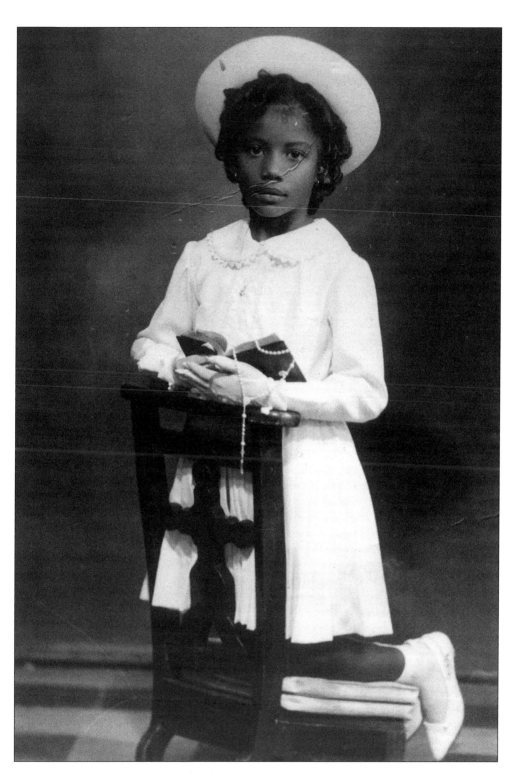
Guithele Ruiz, age 8, at her first communion in Haiti

Guithele Ruiz (left) with State Representative Eleanor Sobel, NAACP National President Kweisi Mfume, and Hollywood Mayor Mara Giulianti

in the community. From the time I could remember, they would work with youth groups to produce talent shows for different functions. I remember there is Ascension, a Catholic celebration. I wore the costumes in the big procession in the street. We were angels throwing flowers and petals on the streets. So, I know my aunts and mom were always involved in organizing those events. They encouraged us, early on, to be active.

"An uncle of mine who was in the military, there was a problem, and he hid at our house. Officers came into our home looking for him. Being that young, I really did not understand, and I started to talk, and I remember my parents were very upset with me. They did not find my uncle at our home. I guess they had anticipated the military coming to look for him so, maybe in the middle of the night . . . I just remember when they looked he was not there. I remember a lot of political chaos. I would hear my parents talk about who died, who was killed. That was under the Duvalier regime. I also remember an aunt of mine that everybody loved. I just kept hearing everybody talking about her and her husband, but I have no recollection of her in Haiti. They were in exile in Cuba. Somehow, I have some vague recollection of close members of my family. In fact, the uncle that I mentioned to you, they ended up killing him. It was, I think, due to an attempt to kill Duvalier's son, Jean Claude. I think, after my uncle died, perhaps my parents became concerned about safety.

"My father was given a fellowship to go to Germany to study. I remember them talking about going away. Then, he sent for my mom, shortly after. He came here, to the U.S., and sent for her. Thinking back, I remember they

decided to leave with the boys. They were the babies. I remember my mother saying, 'You know, you're the oldest. Take care of your [two] sisters.' She'd say, 'I'm going to send you this or that,' just so I could build the courage. I was seven years old. It was a beautiful boarding school. I liked it a lot. I felt very privileged there because it was run by a former teacher of my mom.. We were not like the regular kids who were boarding there. There was another family, and sometimes we felt like we were part of their family because we came in the house with them. Other times, we were just like the other people who were there. My mom would come to visit from time to time. That was very exciting. [We stayed] I think four or five years. It was very structured, stable, sheltered. You'd go to school and church. There were other activities. We'd go spend the summer with an aunt who was still there in Haiti. Overall, I think it was very good. You think back and learn to appreciate. I guess I've learned to appreciate the time spent there. Of course, there were times I'd wish my mom and dad were there for me. I think that's when I developed the independence that I have. I learned to do a lot by myself. Although there were people to comb your hair, I didn't want anybody to do anything for me. I just wanted to do it all. That traced an aspect of my personality.

"As I mentioned, I had an aunt and uncle who were exiled in Cuba and then moved to the Congo, in Africa. My uncle became a diplomat for the United Nations. My father always said, 'You should become an interpreter or a diplomat.' My uncle would encourage me as well. For a very long time I felt that was something expected of me. I was very close to my dad. He said, 'You can do whatever you want. You can be what you want.' When I was in high school, we spent a lot of time together.

We lived in Brooklyn, and he worked in Westchester County at a very small, private school as a teacher. So, I got a scholarship. I was able to attend that school at no cost. We spent about an hour and 15 minutes commuting and that was our time to talk. He pushed for a career, always.

"Haiti is very diverse. There's a very strong influence of Syrians, Arabs, so you really have Haitians of various hues—from very, very fair to very, very dark. Those were not the issues as I grew up. The issue was a class system. You had the elites and a reasonable group of people considered the middle class. They were able to work, own homes, eat regularly, have some comfort as opposed to what the majority of the population that I see is faced with now. So, it was not a color issue. The color became an issue because of the Syrians and Arabs who were the business owners. They were probably better off than a lot of the native Haitians. So, people began to associate money with skin color. The class that you belonged to was skin color. But those were not the issues for us. They were primarily economical. It was who you know, where you go to school. Those are the kinds of things I recall. Catholic and private school versus public school. I grew up in a family where all the women worked. Everybody tried to get into medical school. Those were areas where you had to wait on lists. Those with better means would send their children abroad to Mexico and other parts of the world to study medicine.

"In four days . . . it was so sudden. We landed in Brooklyn, New York. Most of my family lived in a three-story building. It was a tough adjustment; I don't know if it was expectations. Imagine an 11-year-old coming here, not speaking the language. I left all my friends behind. I really felt like a fish without water. My other siblings were much more

fluent in English than French or Creole—the younger ones who came here with my parents. Because they came so young, they were very fluent. So, it was difficult. Another thing I recall is the responsibilities were greater here. Back home, we always had servants. My mom was able to work because somebody was there to take care of the kids, cook, and wash. When I came here, it never dawned on me that I was the one that had to help my parents. I was still young. I would go to my grandmother's and she'd fix dinner, so we ate. I think what I resented a lot was that the boys had nothing to do. We had to wash and iron their clothes. The women really take care of the men. Even as sisters we had to take care of our brothers. Their chores were really nothing compared to what we had to do. They didn't have to take care of their clothes. We took care of their clothes. So, it was an adjustment.

"In 1969, 1970, schools were already integrated. I became very aware of the differences in my race when I went to Riverdale High School. It was predominantly white, and there were about 20 or so African-American students, and we were very close knit. But I remember teachers and students really embracing me to make me feel welcome and part of the school. I used to babysit for one of the Cuban teachers, and even there I felt part of an acceptance with everyone for a very long time. It was the same when I went to a very small all-girl college my first two years. I think being black—my race—really opened many opportunities for me, which is why I really am a product of affirmative action—the scholarships and grants obtained. Even at Riverdale, it was a small group of people, and most of them were on scholarship because the school was really trying to integrate. They would go into the inner city, in Harlem, and recruit. It was an international school, and I finished high school and went straight into college. New York is such a melting pot. I've been very fortunate. I've had people of all groups mentor—black and white.

"When I moved to Florida, people would not believe this, but in 1986 this was my very first [racial encounter]. I was at a conference. My parents already lived here. I worked for a large retail company. I won't say the name. I was visiting the stores, and I heard one of the store managers say, 'Them Haitians. I don't like them coming to my store. They need to be sprayed.' It just shocked me. I think it was at the time, that there was a deluge of refugees coming in, and actually hearing this man saying, 'They smell. I want them sprayed before they come to the store,'—it really hurt me. He didn't know I was Haitian. I don't think I told them at the time. It was my very first encounter with the store manager. I was looking to move down here. My father was always well-dressed. He came to pick me up to go out to dinner, and he was speaking French to me. I said, 'You know, this is what this man said.' He laughed and said, 'Don't worry about it. He's just ignorant.' My dad never really went deeply into what he's experienced, but I think he's always said, 'Don't ever let anyone make you feel different because you're Haitian or because you're black.' That was one of those instances, because he said, 'Look at me. Do you think somebody should spray me because I'm coming to the store?' I said no. He loved to put cologne on. My dad was a good dresser. They thought he was my husband. He was dashing. He loved to dress. He was very elegant. That was my very first time that I faced prejudice because of who I am as a Haitian person.

"[My parents] lived in North Miami. It took me about a year to plan to come. I was coming back and forth. I looked

around. I didn't know where I was going to work. I found this home [in Pembroke Pines] at a home show in New York. One of the developers said, 'When you come down, come over.' This place was like a boondock, and my parents really discouraged me from moving here. I had a sister living in Delray and another in Pembroke Park. So, they really were spread out. [But] I've made a lot of good friends. Back in college there was a small group of African Americans of various backgrounds. I think I became fully aware of the history of African Americans because we were a very small group in high school and college, and black history was always offered in both of those schools. Usually, we would participate in those classes. One woman [and I] were very close. She's a minister, now. We'd spend time at each other's house. Coming down here, some of my best friends are African American. [But] even as an adult, I would go to a party with African Americans and people would tell me, 'You look different.' I had an African-American boss who said I look different. Because of that, I began to feel unaccepted by some people. I'd be hired for a job, and people would say, 'Well, she's not truly black. We want an African American.'

"Working for the Urban League, when I first came down here, I opened my eyes to what Broward County was really like. From an historical perspective, I befriended many of the pioneers. [And] I've seen a lot of changes in Hollywood. There was an older man who I worked for in New York—they were really grooming me; I was on the fast track. They had high aspirations for me, and I said, 'My dad is ill and I really need to go to Florida.' I remember him talking to me and asking, 'Where are you going? To Miami?' I said, 'No, Pembroke Pines.' No one knew where it was. The retailer had a store in Hollywood, and I said it was near there and he said, 'Why on earth are you going there? It's a redneck city. I cannot imagine you going there.' This was a white, middle-aged man in government relations, and I don't know why he said that.

"I've seen a lot of changes in Hollywood. Sometimes I feel I am placed somewhere for a purpose, which is why I took my job in Hollywood very seriously. I felt it was a way for me to [make an] impact, being the first one to create an affirmative action equal opportunity program. I created the first Minority/Women's Business Enterprise Program when people told me it was not going to work, and they've worked. We've gotten many accolades nationwide for some of these projects that I've worked on, up to building communities from the inside out. This is a new Hollywood, from hick town, redneck town back in 1986, to being a catalyst of what the U.S. will be in the [new] century. So it was really rewarding for me to be part of the changes."

*D*eotha Roby moved to Hollywood's Washington Park from Georgia with her daughter, Joyce Dent, in 1953 and was pleasantly surprised by the new opportunities she found even then in Florida life: "It was just street names out here. It was from 56th Avenue to 57th; there was nothing in there. It was bare, just like—as if a hurricane had came by and mashed all those houses down. One house was in the middle of that block, and that was the house I was living in. It was big jack rabbits there, and I thought it was a dog. I never seen a jack rabbit where their ears are so big. And it was jack rabbits from Flagler clean over to Plunkett. Big ears, big rabbits. Never seen such big rabbits. And then they start building these houses. All of this has built up since I've

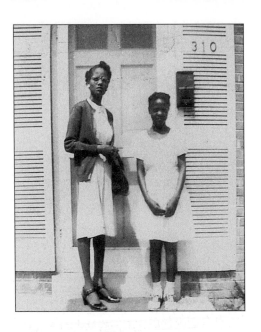

Deotha Roby, age 19, and an unidentified young lady

been here. Pembroke Road wasn't but two trails.

"[In 1953] when I first got here, there wasn't anything organized out here, so to speak, that I knew about. I used to go over to Carver Ranches to their meeting, their homeowner's meeting. I really didn't know what it was all about. Ethel Ferguson, she started the homeowner's meeting out here. At first, I didn't go. My next door neighbor, her name was Dorothy Little, she would always ask me, she'd say, 'Ms. Roby, why don't you come out? You got your own home out here, so why don't you come out and let's all put our thoughts together.' So, eventually I started going into the homeowner's meeting out here. It's got to be the '60s. The first of the '60s, I'd say. [W]e haven't started voting here—having a precinct over here, rather, until about, roughly, I'll say about maybe six or seven years ago. [I]n the back of my mind, voting her was kind of like the voting when I used to vote in Georgia. We had an awful hard time.

"I can remember I said I'll be so glad when I turn 18, I can vote. I didn't know what it was all about. I just heard everybody was voting and I said, well, I want to be in the racket, too. I want to vote, too. So that's what I did. My mama, my daddy—well actually it was my stepdaddy—we all went up there to vote. We all like, a group, went up to the poll to vote, and there was a man standing to the door and told us that you can't vote. So, then, we wanted to know why. But he said, you know, like, 'I don't have to give you an explanation. You just can't vote.' And so we had a veterinarian—God, I don't know what his name is. But, anyway, he seen us coming back out of the courthouse. He asked us, 'Did you vote?' We said no, and he said, 'Why?' We said, well, we were told we couldn't vote. He said, 'I'll go and see why.' And he did. He went in, and he said, 'How come these people haven't vote?' And then, you know, [the man] wanted to change his story then. He said as if he didn't tell us not to vote, you know what I mean? Anyway, he as much told that veterinarian that we couldn't vote, and the veterinarian told us, 'You stay here until I get back. You will vote.' Now, this is a white man talking. When that veterinarian came back with his gun, we did vote. That just left a scar on me because I thought all places was alike. And I said, if we going to have a hard time voting, I'm not going to vote. But then I found out when I got here, it was different. I didn't have that aggravation to go through with.

"Oh, God. I could tell you stories. The guy next door to us had to run and leave his home because of the Ku Klux Klan. There was nothing you could do about it. You see so many of the white people got homes in Georgia because the blacks fled for their lives with the clothes they had on their back. That's all they had. Sure did. It could be that they

come and see why you didn't go to work that day. And they'd say, well, I feel bad. Well, I'm sick, I can't go. They would say, you not sick. In other words, you go anyway. Because that's what happened to my uncle. This wood rider—you don't know about a wood rider. A wood rider is a person, like a supervisor on turpentine quarters. He asked my uncle why he didn't go to work, and would you believe, my uncle told him, he said, I didn't feel too good. He got down off his horse, and he start fighting my uncle. And I know when that come about, I know we were doomed. We were begging my uncle not to hit him. My uncle had done got mad, and that wood rider pulled out a knife. You know what a switchblade knife is? He cut a gash in my uncle's back that long. And every time my uncle would bend over it would just, like that, lay open. I can remember seeing my mama putting some pants and some shirts in the paper bag for him to leave. And he left walking. He ain't left riding because we ain't had no car. And he couldn't write, because he didn't know how to read and write. And the way we had to do that, we had to guess and go to, like, another farm to find out if my uncle had gone there. And that's what we did. That's how we had to find him because we had no letter or nothing that we could send him so he could remember. That's how we found him.

"I have seen [here] there wasn't a black policeman. No blacks hold a seat anywhere. Now it's different. It was at a point where I just thought that was not going to ever happen. Even driving a bulldozer—it was always the other party driving the bulldozer. We would always see the blacks standing up there with a shovel, but not with a bulldozer. Now [in Hollywood] we have blacks on the advisory board; we got blacks as assistant city manager. We have all of that now, but I didn't ever think that I

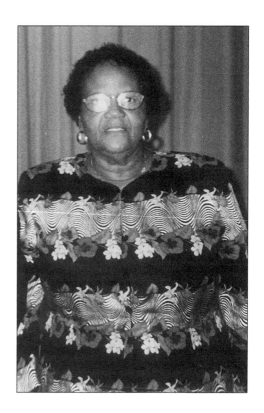

Deotha Roby

would see this. I really didn't because I was brought up, and it was imbedded in me that always it was the white. Always was the white. So, now, I learned. Like, I got a different outlook on things now. Number one—I am somebody. I am proud of what I have learned at this late a date. I'm older, I have experienced more, so now I can tell you something. I was resentful of those people.

"A lot of things, now, I just wish my mother was living to see this, and how hard she struggle with us, trying to raise us the right way. I can remember, my mother never missed a PTA meeting, ever since it started. She was always there. She was always there. Sure did. And I just regret she couldn't go to college because my grandmother said no, that's too far to go from home. My mama just died about—it's almost seven years ago. And she was 108. She

would tell us about when the bell rung for freedom. I believe it was her brother, I believe it was—walked away. He was shelling corn, and the ducks and the chickens was in the corn, and this white lady came and said, 'Don't you have them ducks eat all that corn, and stuff.' He said, 'I'm free now. I don't have to listen to you anymore.' Sure did. He said people was coming all out of the wood work—especially the black—and was clapping their hands. Now they know that those songs that they sang sent messages to the other people—the old songs what they used to sing to let them know to meet me wherever they had this meeting at, under a bush. And they would have their meeting on what their plans was that they was going to do. Can't you believe and visualize seeing Harriet Tubman in this midst?"

José "Pepe" Lopez is executive director of the Latin Chamber of Commerce. Born in Havana, Cuba, he moved to Miami in 1961 at 13 and has lived in Broward County since 1975, where he was hired by the city of Hollywood Police Department: "When I first came in the police department—even though later I got to be president of the Police Benevolent Association and still, until this day I got good relations with the police department in general—it was different. It was [only three] police officers of Hispanic extraction. There were two or three African Americans; that was it. Very few women, I remember two of them only. There was an encounter where one of my sergeants—he became my best friend—but one of the jokes he came up with that 'God now I have an f— Cuban here, then a Negro. What are we going to do with this f— Indian from the Seminole tribe.' It wasn't meant bad; it was a joke and everybody laugh. We laugh, too. If you don't laugh and say anything prior to review you fired, so that was the quietest year in my life. They changed my name and called me Joe and that was fine.

"When I passed probation, I asked them very kindly to refer to me as José or Pepe 'cause I wasn't Joe. But life is a wonderful thing. I have an 11-year-old son named José Lopez, but who wants to be called Joe, so there you go."

Annie Thomas: "[When] I was working and my children were small, we'd hook the screen doors and sleep inside all night. Nobody bothered you. And if my neighbor need something, he would come down to the shop and say, 'Ms. Thomas, I need some flour, or whatever.' I said, 'Well, go in the kitchen and get it.' You know, it was just like that. It was just all family. There was a lot of unity. But, as the years went by, I guess different people start moving in and the drugs came. I wonder where the drugs come from? How did the drugs get started? Drugs started coming in, now more people came in from different areas, you know. Different areas, people would come in and people with different attitudes, different mind, different spirit. So it began to do something to the community. You see the community going down. Like, there were people came in who didn't take pride of where they lived, or of their surroundings, and they didn't have no community pride, no self pride, or no kind of pride. And if I tried to keep up my place, the people next door didn't try to keep up theirs. So, then, here comes the drugs. And that carried the community down. So our community just went down, down. And a lot of things happened, too, when our children grew up. Our children who grew up in this community went to college. When they graduate from college, they come back, and they don't want to live here."

Errol Sweeting was born in Liberia and lived in Broward County for 30 years before moving away. The Attucks High 1965 graduate first returned in 1971. After retiring from the airline industry, he has come back home to Hollywood again, for good: "[In 1971] I became a policeman for the Dania Police Department for about two years. I saw a lot of things happening that opened the door to a lot of things. I was the first black fire lieutenant for Pembroke Park . . . in the '70s, 1973-74. It was a part of the awareness of what had been going on. Getting into the fire department was part of a grant from the government. They were trying to recruit minorities for different things. Not even saying I was truly qualified as a fire lieutenant—I was put there for the knowledge that I had. I had just as much knowledge or better than my white counterparts, and I was the only black there. From there, I saw that I could do things. Doors were opened. I just had a good attitude about things, and I went a long way with it.

"I chose to come back to the old neighborhood . . . I didn't have to, but I chose to come back there because I . . . knew I needed to be around family more. I looked around and said, 'These are not things that I remember.' The old neighborhood had become just that—old. The problems were the same—just the faces change. I didn't see the diversity here was so great until I came back [in 1999]. It wasn't just Cubans. It was other Caribbean nations, and I felt like this was somewhere that I had to learn all over again."

Epilogue

The assignment came from the news editor just a few weeks after I started work. If I had known better, and had not been such a novice, I would have been concerned. It was 1971, and the fervor over busing students out of their neighborhoods to integrate schools was rising to a frantic pitch as white parents throughout Broward County began organizing to fight enforcement of the court ruling. This night meeting would run longer than my 9 p.m. deadline.

People packed in quickly with scowls and placards, lining up to speak at a microphone and voice their rage. And there I was, the lone black face in their midst, armed with only notepad and pen. I steeled myself for the hate. But one after the other they spoke—impassioned, yes, but with a cautious eye towards me as they coached their objections in terms designed not to hit the derogatory racial mark.

I remember that meeting when people ask me now what I have learned from this project, these interviews, these people. The answer they want depends on the source. Historians, like pack rats, are interested in savoring every morsel as they cross-file, dissect, and fact check. Some sociologists want to sift through for patterns and conclusions despite the small sample. Others might argue that people never talk honestly about such an emotionally-charged subject as race—and especially to an interviewer who is not of their background. Like those busing foes, the cautious eye is always turned, gauging just how far they should go. Even same-race subjects may work harder to present themselves in a sympathetic light. We have all kinds of reasons not to talk—or not to listen.

But storytelling has rewards not only for the teller, but for the audience as well. Through the experiences of others we often see ourselves a little bit clearer. Blacks and whites may still be on different sides of the tracks, perhaps more figuratively these days than in the past. In Hollywood, *Money* magazine called them "enclaves." But we share a common history because we can all bear witness to some part of the last four decades of social change in this country. At the same time, people of other nationalities and views on race are nudging us closer together.

The people featured in this book were solicited from various city organizations and through a wide network of referrals. They opened their homes and their lives with few reservations. Interestingly, several were already involved in projects on a smaller scale, trying to figure out how to preserve some part of their family or community history. Concentrating on questions regarding *specific personal experiences* rather than general observations, opinions, or secondhand information kept the interviews focused and triggered a wealth of detailed memories. As these stories are shared, hopefully they will spark further dialogue about what one Hollywood resident called "the American thing," this issue of race that perplexes and affects us all.

This project has been like a peek into our collective psyche for me—shortcomings and all. Perhaps other communities will launch similar efforts.

After each of my hour-long sessions, once the tape recorder finally clicked off, a lingering goodbye would begin. Sometimes I would get hugs that felt like mutual relief. Later I would realize that, at some point early on during the interview, my initial feeling of fear had dissipated—and I wasn't even aware at the time. But at each parting I knew I would remember *that* voice for a long time to come.

Claude David (left) and Leroy Saunders

Photograph Credits

The following institutions generously provided images from their collections for this publication:

Page 5: Courtesy of the Fort Lauderdale Historical Society
Page 10: Courtesy of Broward County Historical Commission
Page 11, top: Courtesy of the City of Hollywood Records and Archives
Page 11, bottom: Courtesy of the Fort Lauderdale Historical Society
Page 16: Courtesy of the Florida State Archives
Page 18: Courtesy of the Florida State Archives
Page 24: Courtesy of the Broward County Historical Commission
Page 25: Courtesy of the City of Hollywood Records and Archives
Page 26: Courtesy of the Fort Lauderdale Historical Society
Page 27: Courtesy of the Hollywood Historical Society, Inc.
Page 28: Courtesy of the City of Hollywood Records and Archives
Page 32: Courtesy of the Fort Lauderdale Historical Society
Page 33: Courtesy of the Broward County Historical Commission
Page 34: Courtesy of the Fort Lauderdale Historical Society
Page 36: Courtesy of the Florida State Archives
Page 41: Courtesy of the Fort Lauderdale Historical Society
Page 43: Courtesy of the Fort Lauderdale Historical Society
Page 44: Courtesy of *Sunshine Magazine*, the *Sun-Sentinel*
Page 47: Courtesy of the Fort Lauderdale Historical Society
Page 51: Courtesy of the Fort Lauderdale Historical Society
Page 53: Courtesy of *Sunshine Magazine*, the *Sun-Sentinel*
Page 54: Courtesy of the Broward County Historical Commission
Page 56: Courtesy of Broward County Historical Commission
Page 58: Courtesy of the Florida State Archives
Page 59: Courtesy of the Broward County Historical Commission
Page 60: Courtesy of the Florida State Archives
Page 63: Courtesy of the Fort Lauderdale Historical Society
Page 64: Courtesy of the City of Hollywood Records and Archives
Page 67: Courtesy of *Sunshine Magazine*, the *Sun-Sentinel*
Page 68: Courtesy of the Broward edition of the *Herald*
Page 69: Courtesy of Kevin Swan, South Broward High Yearbook, 1966
Page 72: Courtesy of Kevin Swan, South Broward High Yearbook, 1966
Page 74: Courtesy of the City of Hollywood Records and Archives
Page 79: Courtesy of Kevin Swan, South Broward High Yearbook, 1966
Page 80: Courtesy of *Sunshine Magazine*, the *Sun-Sentinel*
Page 81: Courtesy of Kevin Swan, South Broward High Yearbook, 1966
Page 84, top and bottom: Courtesy of the Fort Lauderdale Historical Society
Page 87: Courtesy of the Fort Lauderdale Historical Society
Page 91: Courtesy of *Sunshine Magazine*, the *Sun-Sentinel*
Page 93: Courtesy of the Broward edition of the *Herald*
Page 104: Courtesy of *Sunshine Magazine*, the *Sun-Sentinel*
Page 108, top and bottom: Courtesy of the Broward edition of the *Herald*
Page 127: Courtesy of *Sunshine Magazine*, the *Sun Sentinel*